NASHVILLE

BEHIND THE CURTAIN

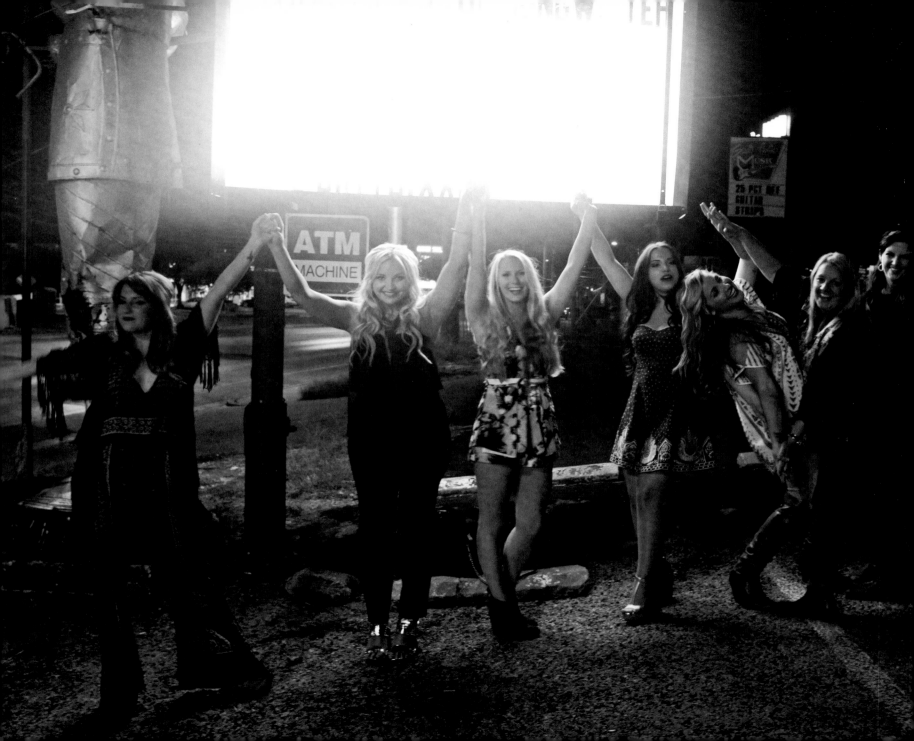

NASHVILLE

BEHIND THE CURTAIN

PHOTOGRAPHY BY
SONYA JASINSKI AND KATE YORK

FOREWORD BY
KACEY MUSGRAVES

INTRODUCTION BY
NATHAN FOLLOWILL

AFTERWORD BY
HOLLY WILLIAMS

INSIGHT EDITIONS

San Rafael, California

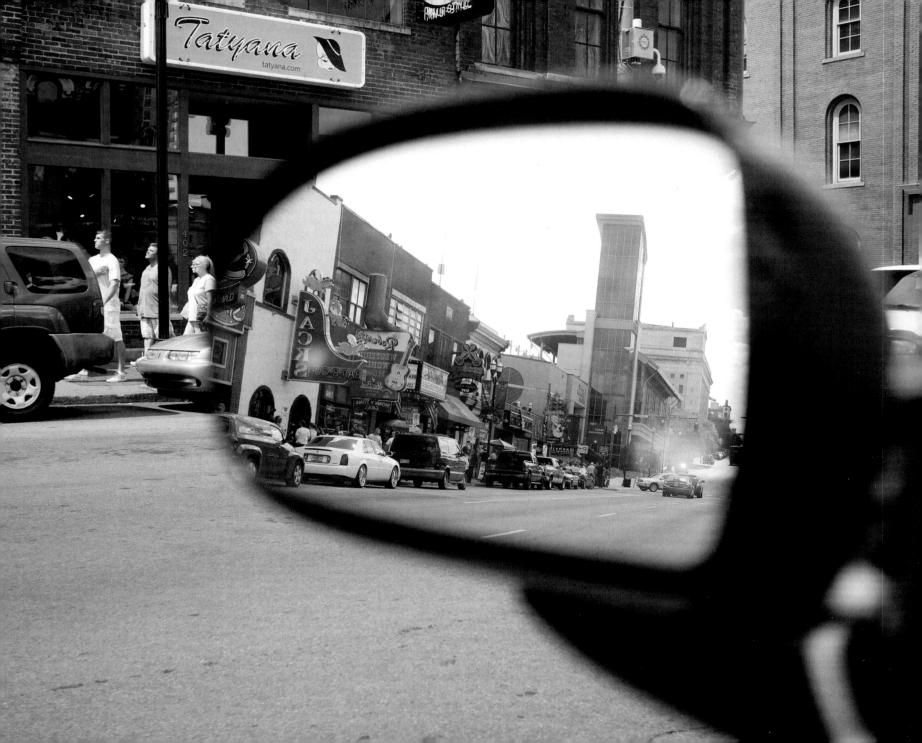

CONTENTS

FOREWORD 6

INTRODUCTION 11

BEHIND THE CURTAIN 12

LITTLE BIG TOWN 18

BROTHERS OSBORNE 25

LUCIE SILVAS 28

EMMYLOU HARRIS 31

HAYDEN PANETTIERE 33

CHIP ESTEN 36

NATHAN FOLLOWILL
AND JESSIE BAYLIN 41

CONNIE BRITTON 48

MAREN MORRIS 54

HOLLY WILLIAMS 57

CLARE BOWEN 60

RAYLAND BAXTER 63

ERIN McCARLEY AND K.S. RHOADS 65

EMILY WEST 68

WHO IS FANCY 71

LENNON & MAISY 75

BOB HARRIS 76

KACEY MUSGRAVES 78

SAM PALLADIO 86

MARY STEENBURGEN AND TED DANSON 89

T BONE BURNETT AND CALLIE KHOURI 93

SARAH BUXTON AND TOM BUKOVAC 95

CHARLIE WORHSAM 98

TRISTEN 100

LEE ANN WOMACK 102

NATALIE HEMBY 105

BARRY DEAN 108

BUSBEE 110

MICKEY GUYTON 113

DEAN AND JESSIE JO DILLON 114

JAY JOYCE 118

J.D. SOUTHER 121

BRANDY CLARK 122

F. REID SHIPPEN 125

SHANE McANALLY AND JOSH OSBORNE 127

ASHLEY MONROE 128

KREE HARRISON 131

MATRACA BERG 133

CAITLIN ROSE 134

HUNTER HAYES 137

JAMES KICINSKI-McCOY 138

CHRIS DIFFORD'S
SONGWRITING RETREAT 141

CHRIS GELBUDA 144

IAN FITCHUK 145

KEN LEVITAN 146

JACK SPENCER 149

KRIS KRISTOFFERSON 151

LIZ ROSE, LORI McKENNA,
AND HILLARY LINDSEY 152

LUCINDA WILLIAMS 154

BUDDY AND JULIE MILLER 158

PATRICK CARNEY 160

LEIGH NASH 161

AFTERWORD 162

ACKNOWLEDGMENTS 166

FOREWORD

PACKING UP MY THIRD-FLOOR APARTMENT in Austin, pissing a few people off, squeezing everything into my car, and driving through the rain to Nashville was the best decision I ever made. I felt immediately (though sometimes uneasily) at home in the house I'd rented, sight unseen, between Sixth and Seventh on Shelby Avenue. After singing as many demos and harmonies as I could handle, enduring boring writers' nights, dressing up for children's birthday parties and getting paid in change, making flyers for housecleaning jobs (and seeing my one housecleaning job get canceled), I finally got a gig writing for a living. I was twenty-one. I couldn't believe I could actually make money sitting on my ass and taking words out of my brain. That opportunity, single-handedly, gave me everything I have today. I would have nothing without songs—songs that could have only been written in that time and space, under those circumstances, under that leaky roof on Shelby, and created with the gifted souls who make Nashville one of the most unique places in the world. Souls who came there just like me. These songs have given me the chance to see the world. To sing with my heroes. To smoke with my heroes. And to just plainly figure myself out.

So many indescribable, unbelievable things have happened in such a short time. I'll never forget meeting and harassing John Prine at the Station Inn as a fan several years ago, then playing a life-changing show with him this year—just us two and our guitars. Getting yelled at by Brian Wilson. My underwear legitimately (and accidentally) falling off three seconds before the curtain

OPPOSITE: Kacey Musgraves on Villa Place, a street home to many Nashville songwriters and musicians.

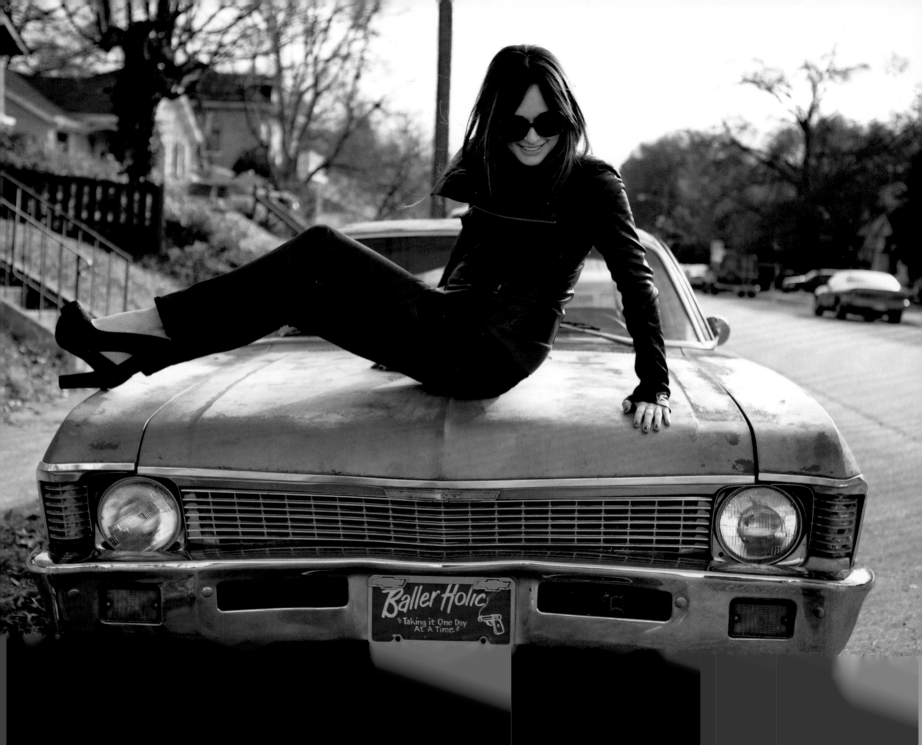

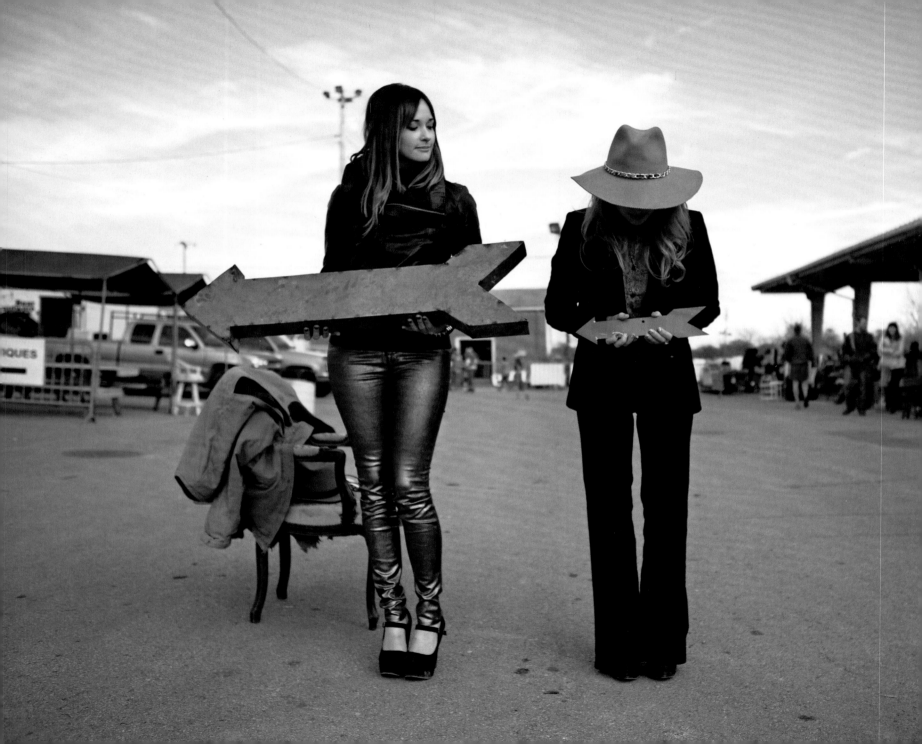

opened on a live TV performance in a short dress with—oh, just a lifelong inspiration—Loretta Lynn. Traveling the world with some of the best and most talented people I've come to know. Breaking down on the side of a mountain. Laughing, crying, laughing *till* I'm crying, dancing, drinking, singing, fighting, buying, writing . . . filling my camera roll and notebook with bits and pieces of what already feels like a fifty-year career.

Jumping into a $5 photo booth with Willie Nelson. Hearing stories about his horses (all seventy-five of them) after a long and whimsical day of shooting a video (and tequila) together in Texas. Getting to hear and ask him about all my favorite songs. Watching him kick out his still-young melodies and trying to keep my shit together. Walking the red carpet with my grandparents. Roller-skating with Katy Perry. Being portrayed by drag queens. Rescuing and buying my childhood home and painting it pink. Being called the wrong name in front of a huge crowd by Vince Gill, then being sent an equally huge flower arrangement as an apology. Seeing friends succeed. Being a Jeopardy clue. Ordering room service we couldn't afford and dancing barefoot till morning the night of the Grammys but never taking off our light-up suits. Tripping in Joshua Tree. Failing at radio. Selling out the Ryman for the first time. And so many more treasures that would take a lifetime remembering. When I'm old and wrinkled and my rhinestone shorts don't fit anymore, I'll be proud to have the songs—and the gratitude for the town that gave them to me.

—KACEY MUSGRAVES

OPPOSITE: Kacey Musgraves and British singer-songwriter Lucie Silvas at the Nashville Flea Market, making a reference to Musgraves's hit single "Follow Your Arrow."
FOLLOWING PAGE: Nathan Followill of the Kings of Leon by the pool at his home in Nashville.

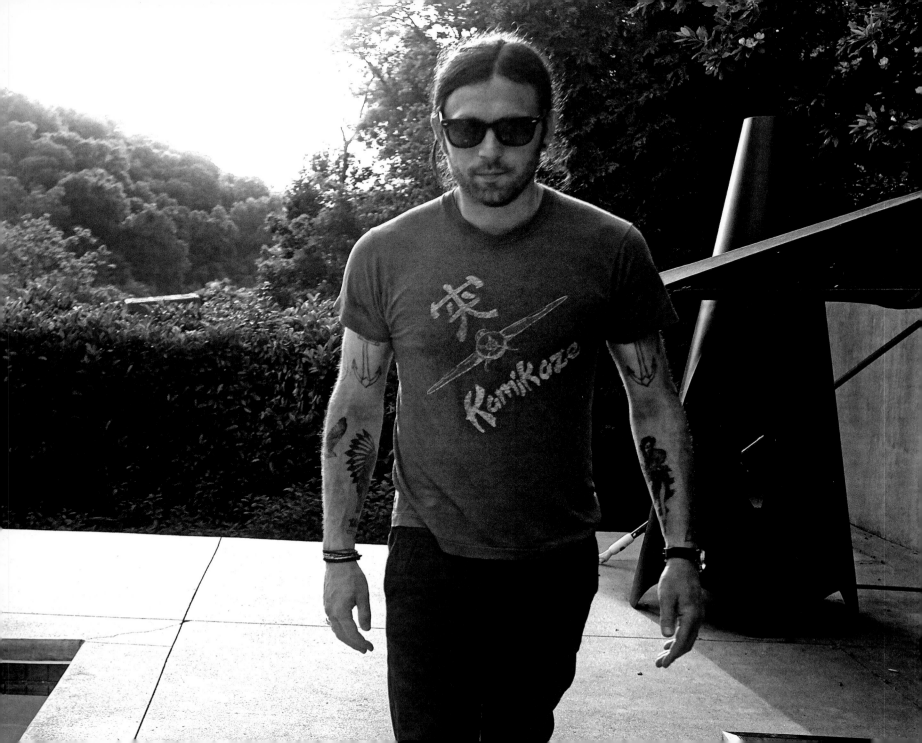

INTRODUCTION

THE MOST INFLUENTIAL PERSON I've met in Nashville is definitely Angelo "don't forget the cornbread" Petraglia. When we first started writing here, we quickly learned that it was a very formulated, quick turnaround process (cutting a demo the same day). After a month of writing three sessions a day, we were getting a little burned out.

Seeing the state we were in, our manager, Ken Levitan, suggested we meet this cat named Angelo. We went to his house, which smelled of nag champa, whiskey, and wisdom. We were amazed at all of the cool shit he had: instruments older than our parents and a vinyl collection to die for. We, being the good preachers' sons that we were, had never heard much rock 'n' roll, and we were blown away hearing the Stones, Television, and Led Zeppelin for the first time. Angelo opened our eyes to a musical world much bigger than country music and inspired us to aim higher—and to get higher on the weed. He took us from kids to Kings, and from that point forward we never looked back. Thanks, Angelo.

We've grown into this city a lot since that night at Angelo's. My brothers and I traveled for most of our childhood and never really had a "home," so when we bought our band house and started hosting friends for "inspirational" get-togethers, I truly felt like we'd found a place to put down roots. I'll never forget selling out the Ryman for the first time and feeling like Nashville had finally accepted us as their own. I still get chills watching video from that show.

Nashville has changed over the years: better restaurants, worse traffic, and a much bigger music scene outside of country music. Unfortunately, the bedazzled crosses on denim shirts and jean pockets aren't going anywhere, but fingers crossed. With more good things coming, much has stayed the same. I still love catching a show at the Ryman and going to Robert Western World afterward for cold beer and hot bologna, or going to Radnor Lake, to clear my head.—**NATHAN FOLLOWILL**

BEHIND THE CURTAIN

WITHIN TWENTY-FOUR HOURS of flying into Nashville from England while visiting my best friend, Lucie Silvas, I found myself sitting in a house on Villa Place, which runs parallel to the infamous Music Row. I sat surrounded by young girls and guys jamming and singing, taking polite turns or gradual song transitions with a fluidity that was almost telepathic. There was a mutual respect between every musician and a generous offering to everyone who took the imaginary stage momentarily. Watching a guitarist picking at his guitar with the drummer tuning in on his chords, a singer diving into a song with everyone harmonizing—it was how I imagined the '70s era would have been. The only place this kind of music community existed in this era, in this way. I was truly enamored by Nashville's spirit.

It was on my second visit to Nashville that Lucie said, "I have this incredibly beautiful and talented friend, Kacey—you should photograph her. I swear she's going to win Grammys." A few days later, Kacey turns up at the house on Villa, and the three of us wind up sitting on my guest bed doing makeup, giggling, chatting. Both of these girls had an energy about them that lit up the room. Eventually Kacey and I went outside to start shooting. Jumping on neighbor's cars, into yards. We started momentum and the fun began. We wound up at the Nashville flea market, making friends with the vendors, trying on all their clothes, playing with their flags. That was my first Nashville shoot, and that tone—playful and casual, but also intimate—set the tone for the project that would become this book.

Days later, I met the force that is Kate York. A singer-songwriter, she knows everyone in this town. We met each other at a show at The Basement. It was during that same trip that I became introduced to a band called Little Big Town. I thought they were Country's version of Fleetwood Mac, and learned about how hard this band had worked to get to where they are today. Blood, sweat, and tears it took them. For a foursome to be that committed for that long really is

OPPOSITE: Photographer Sonya Jasinski at the Nashville Flea Market with Kacey Musgraves.

FOLLOWING PAGE: Jasinski at Blackbird Studios with TJ Osborne of the country music duo the Brothers Osborne.

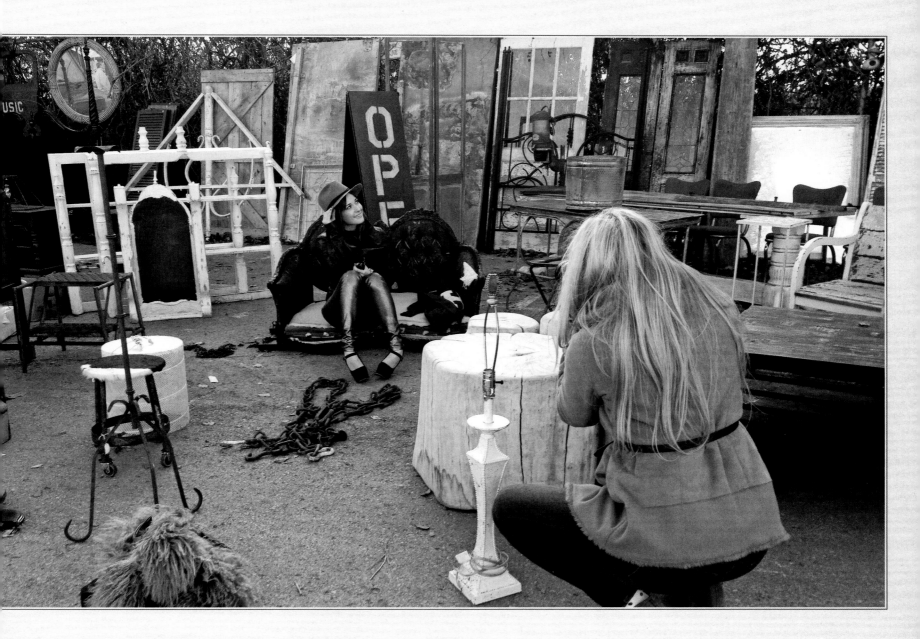

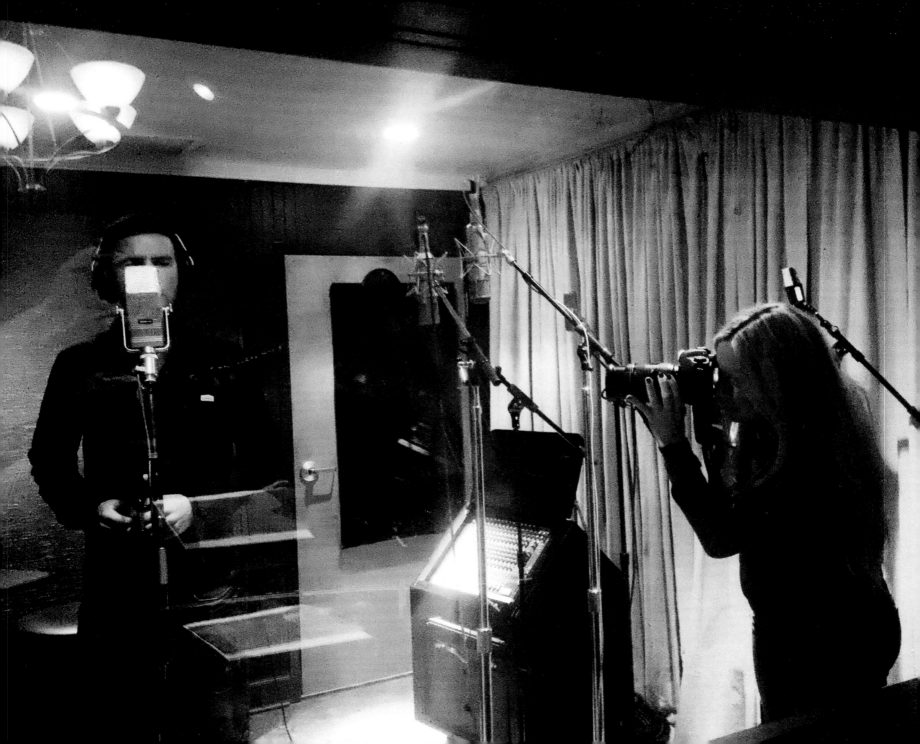

something special, and in typical Nashville style, they're always warm and hospitable. Little Big Town beams, but they were just the start for me.

As a visitor to this city, I was hooked on the talent I saw everywhere around me, and fell in love with the raw musical talent that pervades Nashville. I was meeting songwriters who had such a gift for words that they blew me away with every sentence they spoke, so impressed was I with their gift for words and how much emotion they felt. They put all that into their songs, whether they were singing on porches or on the radio. I met guitarists who blew my soul away and I learned how committed to their instrument they were growing up, singers who have had challenging childhoods and still persevered, producers who stayed up all night, night after night, sleeping in intervals to get it right. I couldn't believe how talented everyone was behind the music—in all its elements, across the board. This town lives and breathes music, and the people here support each other, whether by swapping instruments, playing shows with friends, or packing the house at gigs. The generosity is limitless.

Since those first visits, I've flown over regularly from the UK to photograph artists for their album work and promotional material. Kate and I struck a bond and a common interest in photography. She showed me candid material she had taken of her closest friends, and it blew me away. We saw photography in a similar way—we both loved spirited, unstaged, and sometimes messy photos. No air brushing. Very rock 'n' roll, very real. This book came out of that bond and out of the Nashville spirit that has moved us. Growing up on Patsy Cline, I never thought I'd have the opportunity to capture this city on film.

I hope these pages show a glimpse of Nashville's talent behind the music as well as in front, a great cross section of everyone who builds a record, including the lives that are led at home, in the studio, or at a bar. I feel like the luckiest photographer in the world, bar one regret—I once packed up my camera too soon and missed a shot of Ted Danson folding his laundry.

As for the group of talented Villa folk who used to jam out at 1501 Villa Place, every single one has gone on to achieve incredible accomplishments—Kacey Musgraves, Brothers Osborne, Kree Harrison, Charlie Worsham . . . and more.—**SONYA JASINSKI**

I LEFT CALIFORNIA AND MOVED TO NASHVILLE in 1999 to pursue a life in songwriting. Growing up, my family and I never lived anywhere longer than three years. I never knew what it was like to stick around for heartbreak, or see a building fall and become something else. My parents took all the pictures back then, and most of my memories from my twenties in Nashville are only in my mind. I have a few rolls of 5 x 7 glossies under the bed, but that's about it.

It wasn't until three years ago that I realized what was happening around me and started to pay attention. I began shooting experiences I was in the middle of—from songwriting sessions to hanging out on the road with a touring friend. Capturing candid and intimate moments gave me a shot in the arm like nothing I'd felt before. I'm a songwriter first and an accidental photographer second.

Around the same time I discovered my love for photography, I met Sonya. She was a photographer from London who would occasionally shoot in Nashville. After traveling and taking photos together in London, Barcelona, and Mallorca, we decided to shoot as a team. We embarked on a three-year journey, shooting as many Nashville creatives as we could. So many wonderful people are involved in the creation of a song, from the moment when the pen hits the paper to the one when the album hits the shelves. We wanted to shine the spotlight on the whole process and not just the end result. We ended up capturing moments we couldn't have dreamed up. Nashville is magic like that. You never need a plan in this town. It just carries you along for the ride. We will never be able to thank everyone who participated in this enough.

Every photo is a song, and we dedicate this book to you, Nashville.—**KATE YORK**

OPPOSITE: Kate York on a late-night shoot with actress Hayden Panetierre, at The Fairgrounds Nashville.

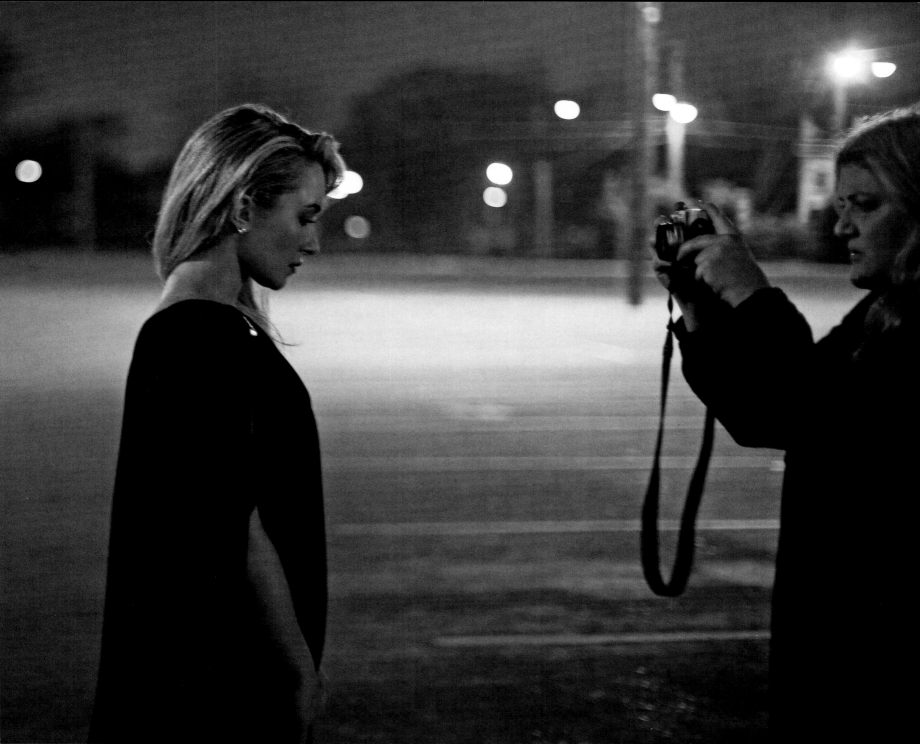

LITTLE BIG TOWN

OUR FIRST PERFORMANCE in public, as a band, was at the Grand Ole Opry sixteen years ago. I can still remember looking across at Kimberly while we were standing in that sacred circle, thinking, "How did we get here?" We were two college friends who had dreamed of Nashville, dreamed of singing and starting a band. Since that day, there's been a lot of miles traveled and a lot of life lived, a lot of songs written, a lot of music made, and a lot of love shared between the four of us. We were surprised a few months back to be invited to be members of the Grand Ole Opry. There we were, standing in that circle again, looking at each other and wondering, "How did we get so lucky?" It was a full-circle moment, standing in the circle where legends and icons have stood before. I don't think anything could be much sweeter than that.—**KAREN FAIRCHILD**

THIS PAGE: Backstage moments with the band behind the hit single "Girl Crush." OPPOSITE: From left: Kimberly Schlapman, Phillip Sweet, Karen Fairchild, and Jimi Westbrook. FOLLOWING PAGES: Karen Fairchild prepares to go on; Fairchild and Westbrook sing a harmony onstage at the New Orleans Jazz Fest.

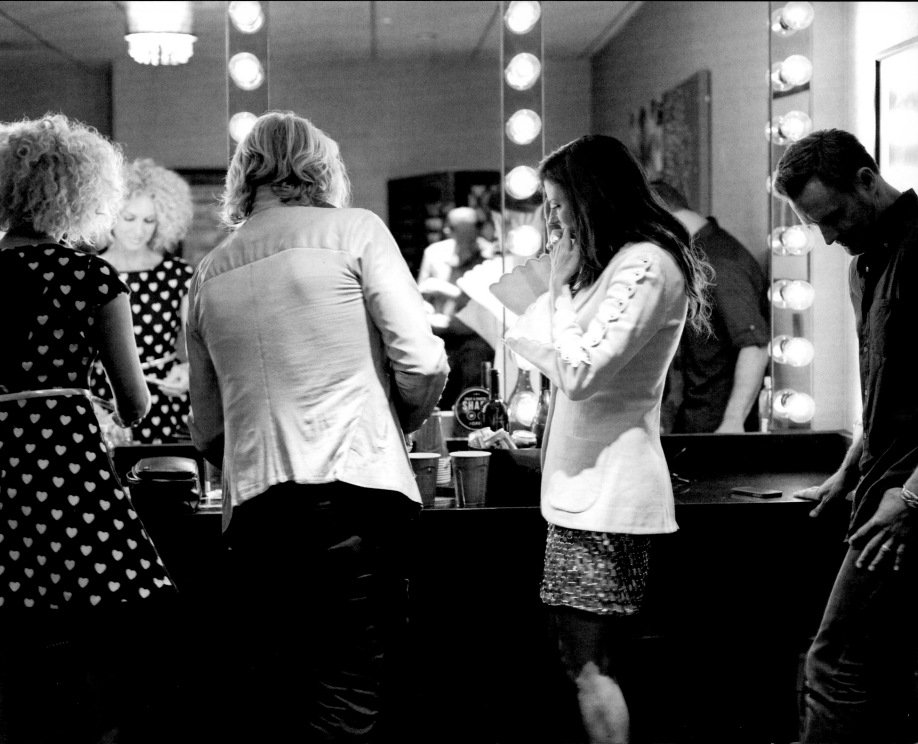

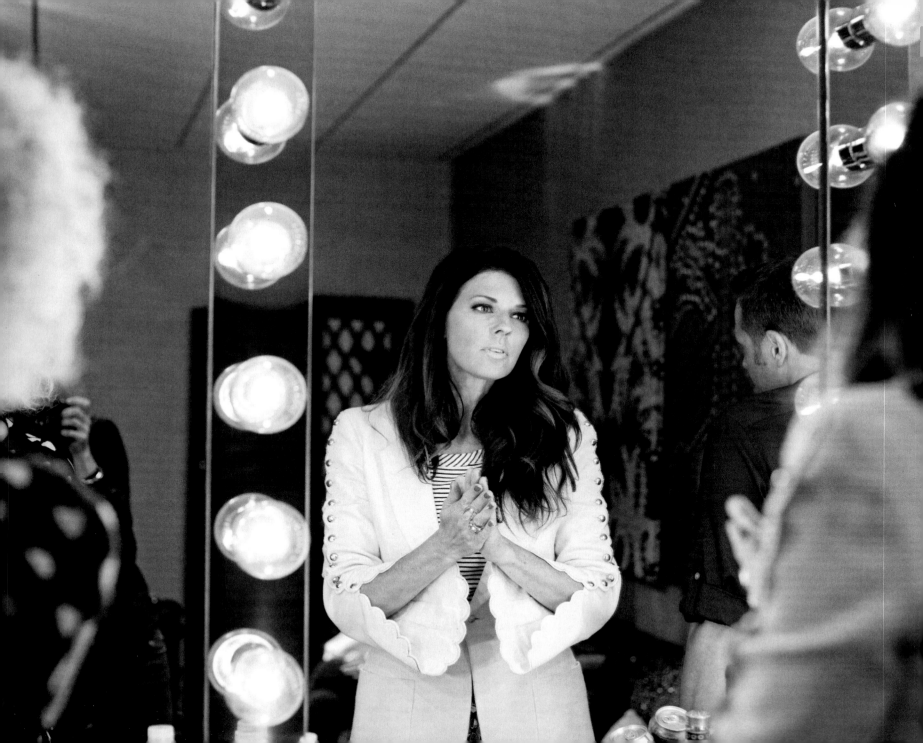

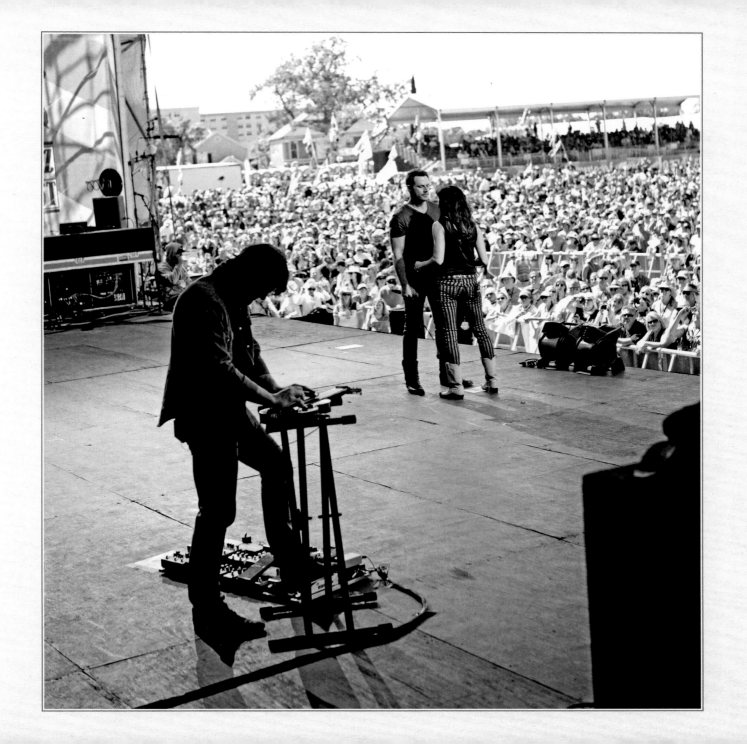

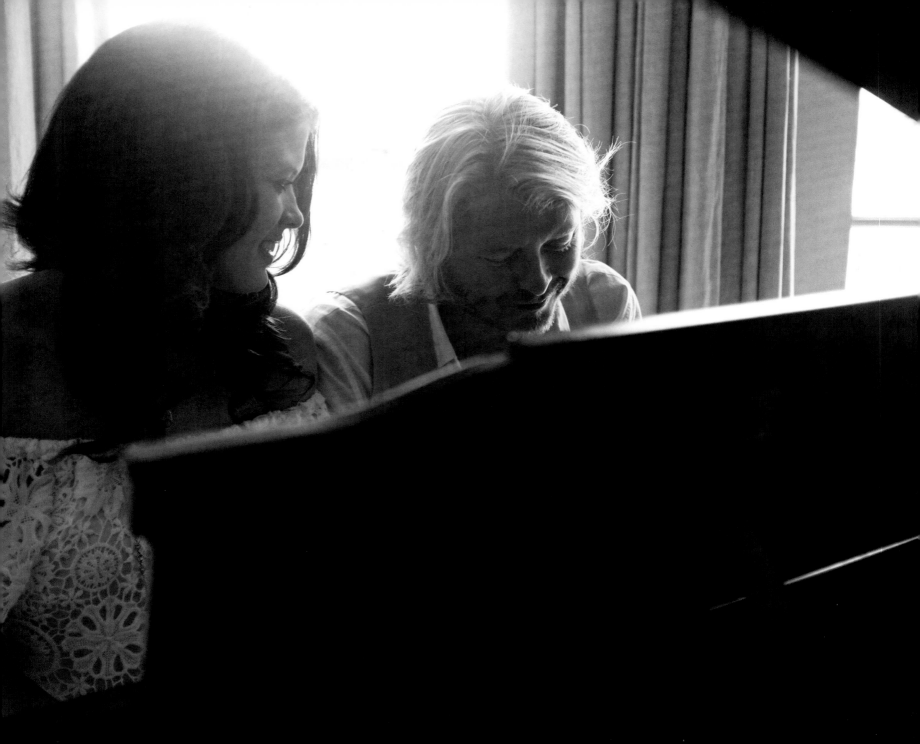

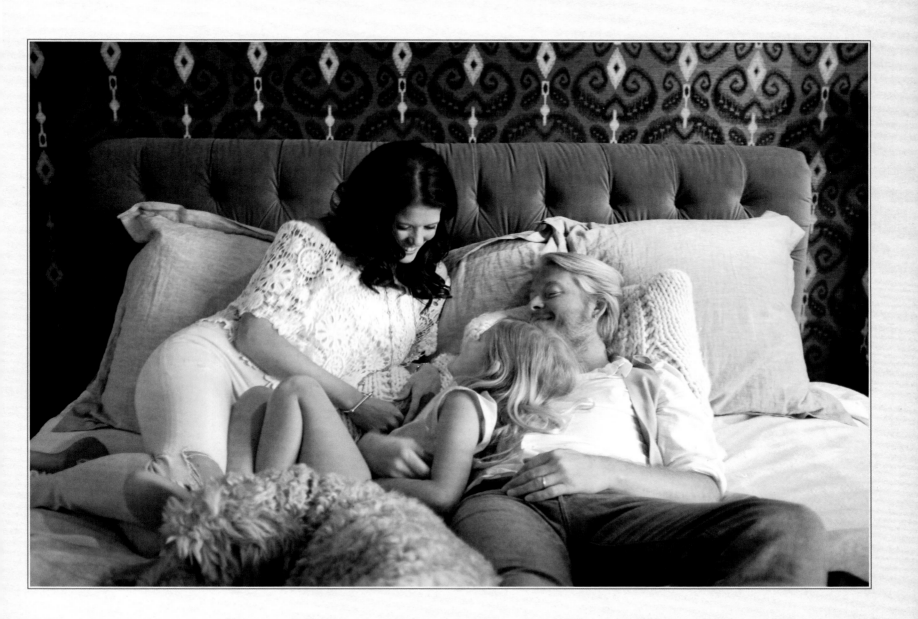

THESE PAGES: Little Big Town's Phillip Sweet at home with his wife, Rebecca, and their daughter, Penelopi.

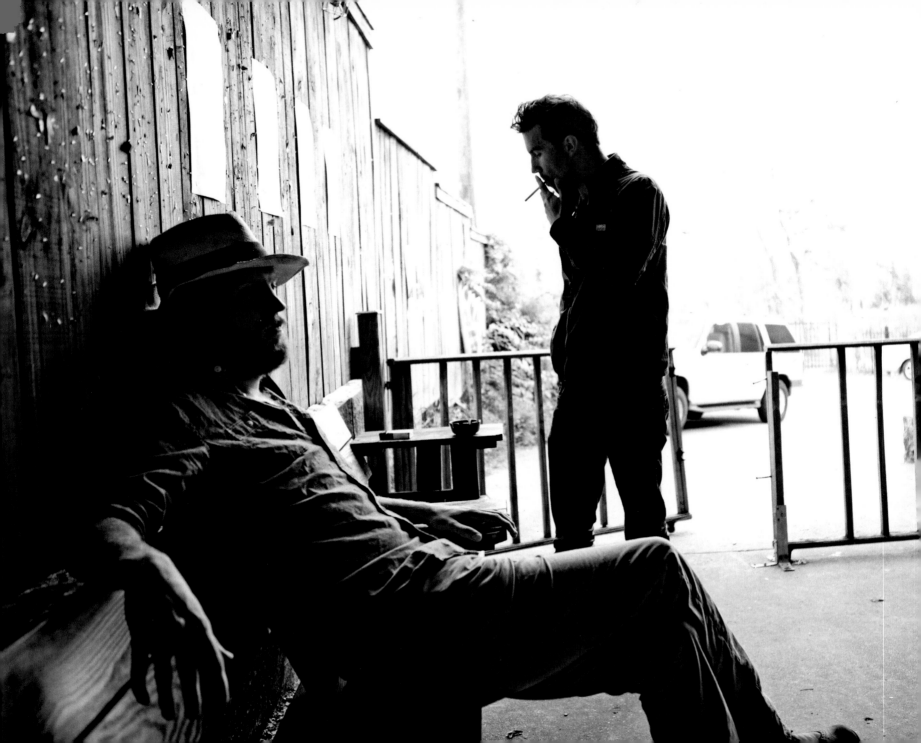

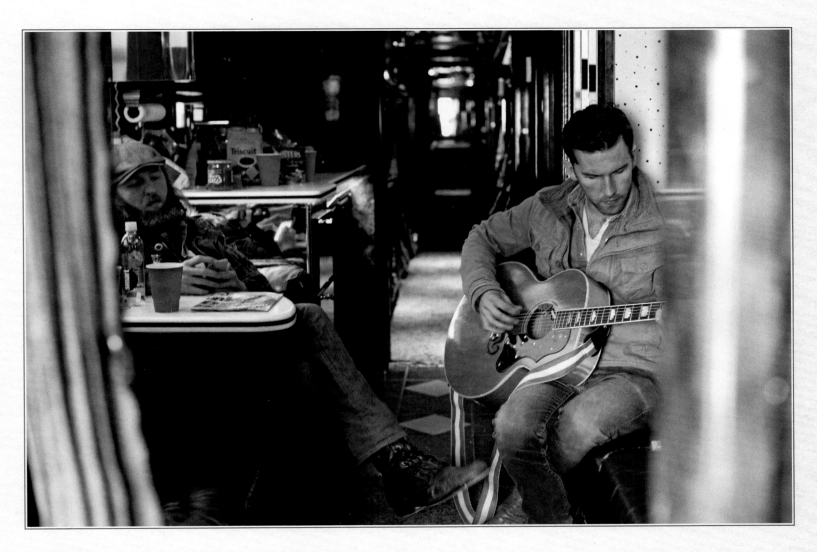

ABOVE: Downtime on the tour bus, parked at the Bushwacker's Saloon in Omaha, Nebraska. OPPOSITE: Brothers TJ and John at The Basement in Nashville.

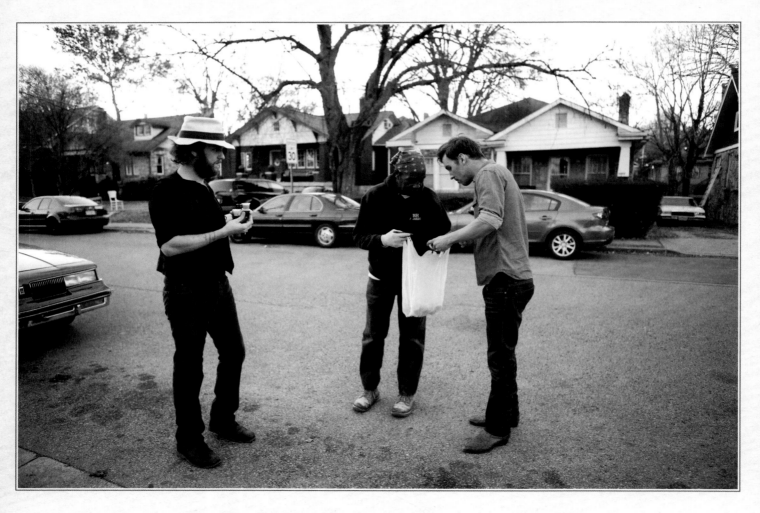

"We got offered our record deal at The Basement. Grimey, the owner, has been such a champion for new music in Nashville. We'll forever cherish that small but mighty venue." —JOHN OSBORNE

ABOVE: Getting jello vodka shots from a neighbor on Villa Place.
OPPOSITE: Brothers TJ and John at The Basement in Nashville.

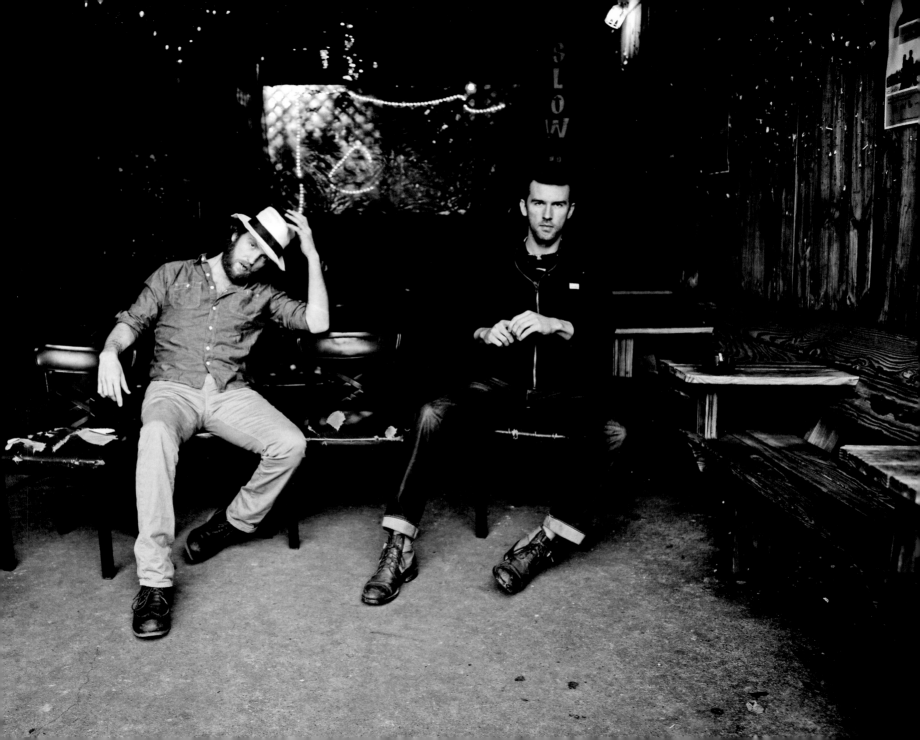

LUCIE SILVAS

SINGER, SONGWRITER

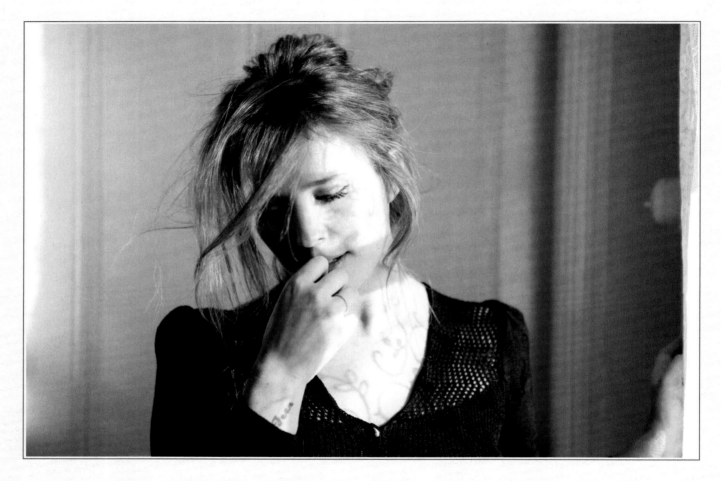

"You can walk into a coffee shop in Nashville and start casually chatting to someone who wrote one of the greatest songs of the decade. They're all here."—LUCIE SILVAS

THIS PAGE: British singer-songwriter Lucie Silvas at Judie Tzuke's house in Surrey, England. OPPOSITE: Silvas with husband, John Osborne, at their home in East Nashville.

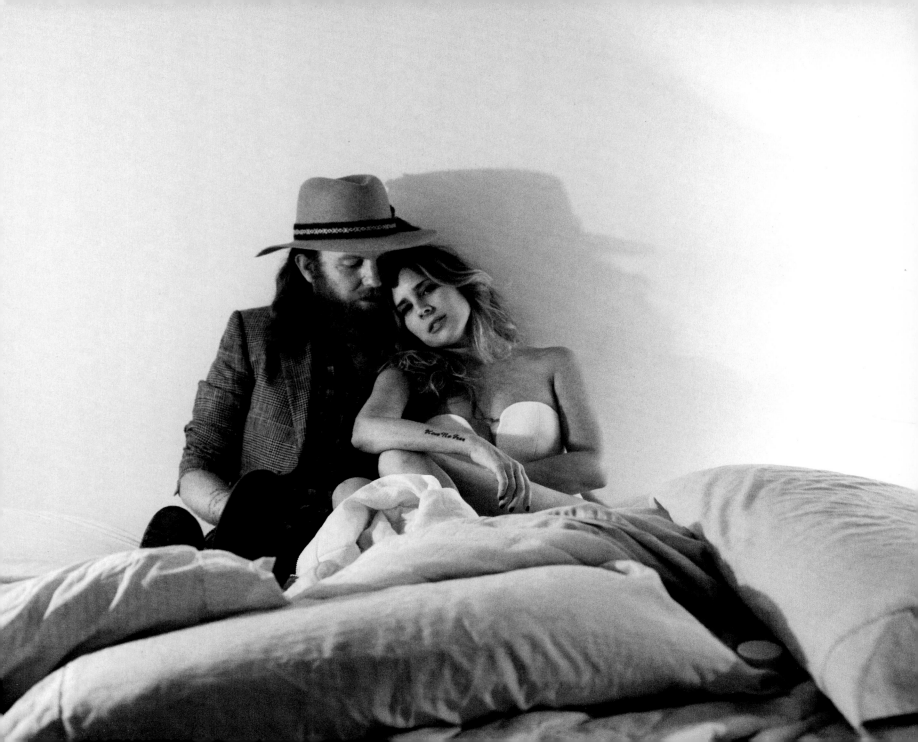

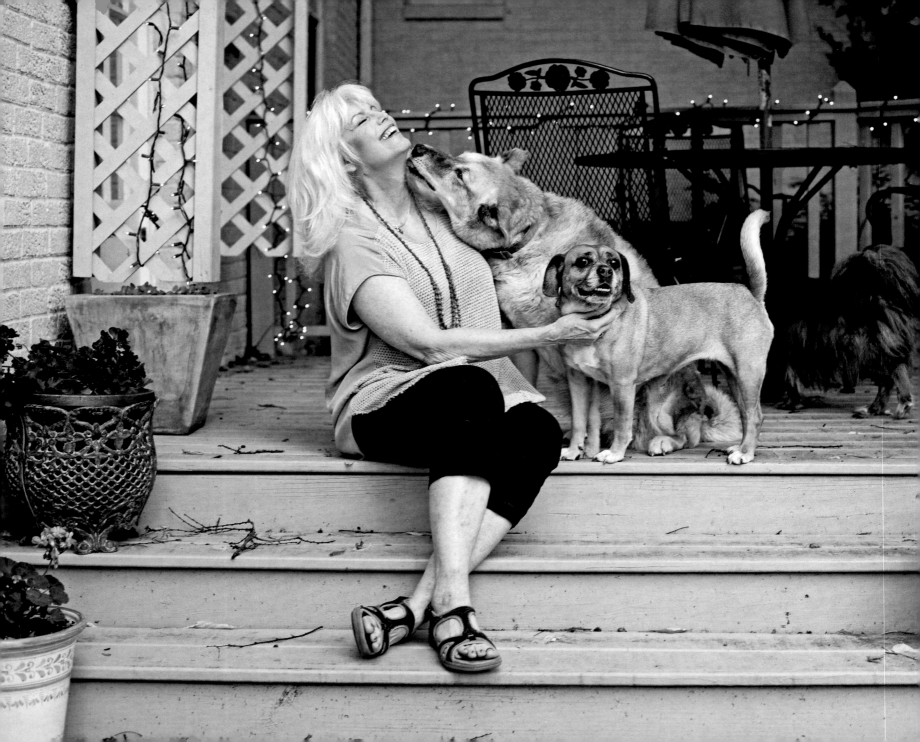

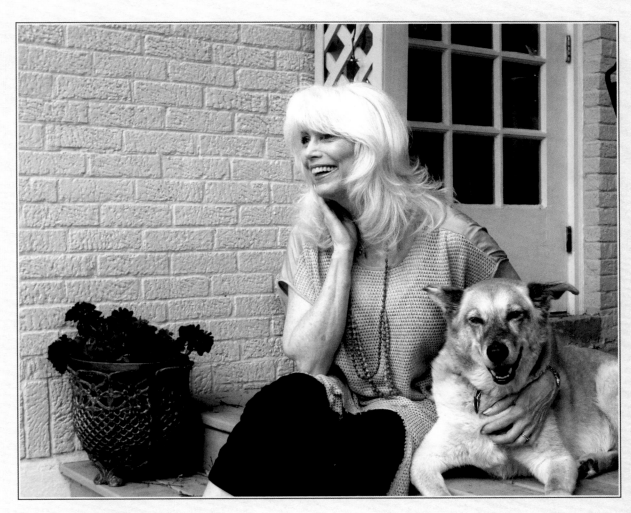

THESE PAGES: Emmylou Harris at home with her beloved dogs. An active member of PETA, Harris founded Bonapart's Retreat, an animal shelter in Nashville.

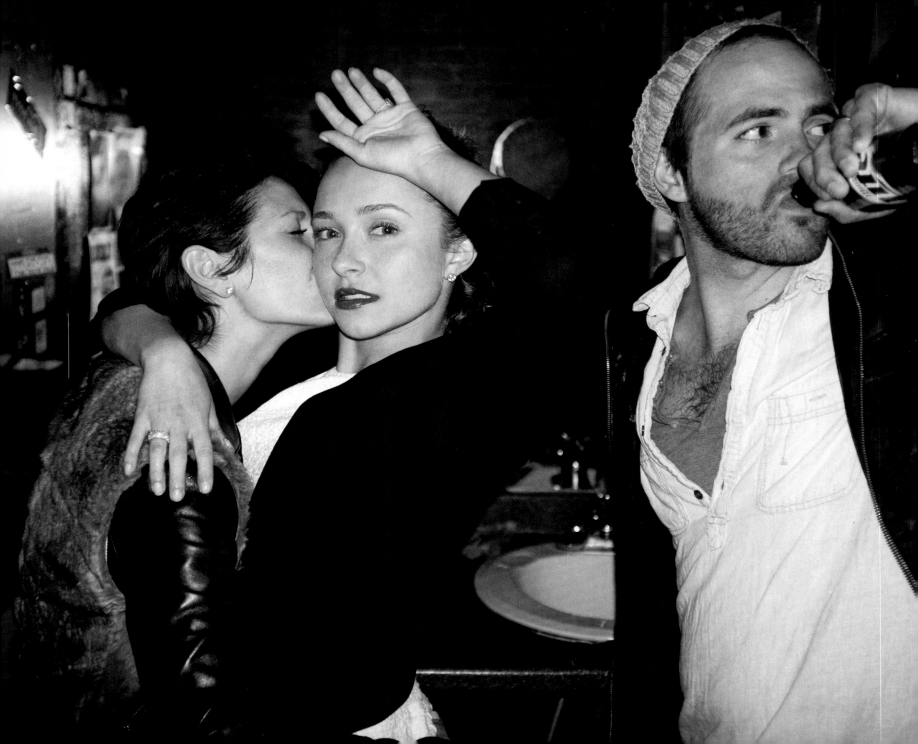

HAYDEN PANETTIERE
ACTRESS, MODEL, SINGER, ACTIVIST

OPPOSITE: Hayden Panettiere with Leisa Dupree Hans and Tommy Hans in the girl's bathroom at The Basement. THIS PAGE: Panettiere with Santa at Santa's Pub, a well-known karaoke bar in Nashville. FOLLOWING PAGES: Late night at The Fairgrounds Nashville; Panettiere at her home in the Hollywood Hills.

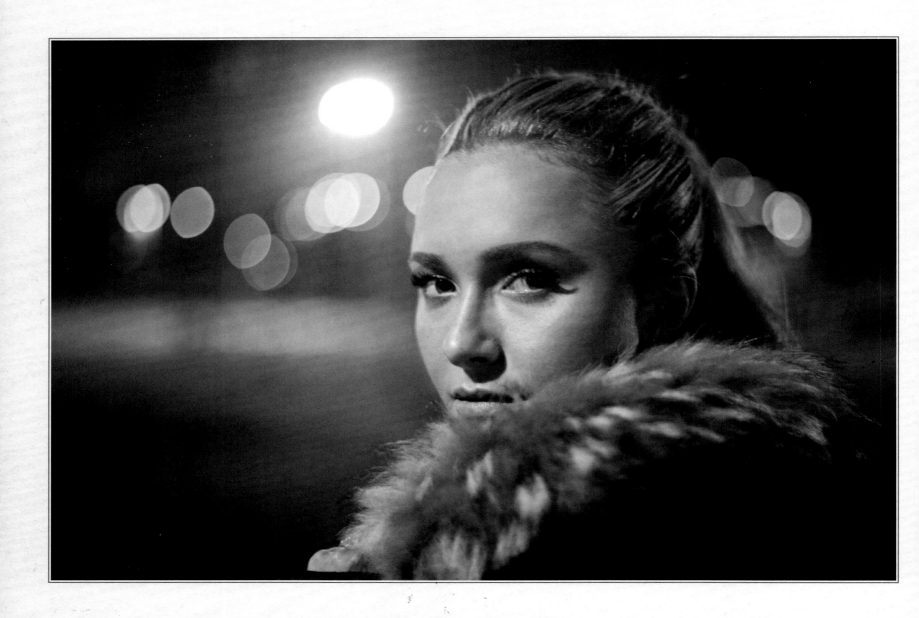

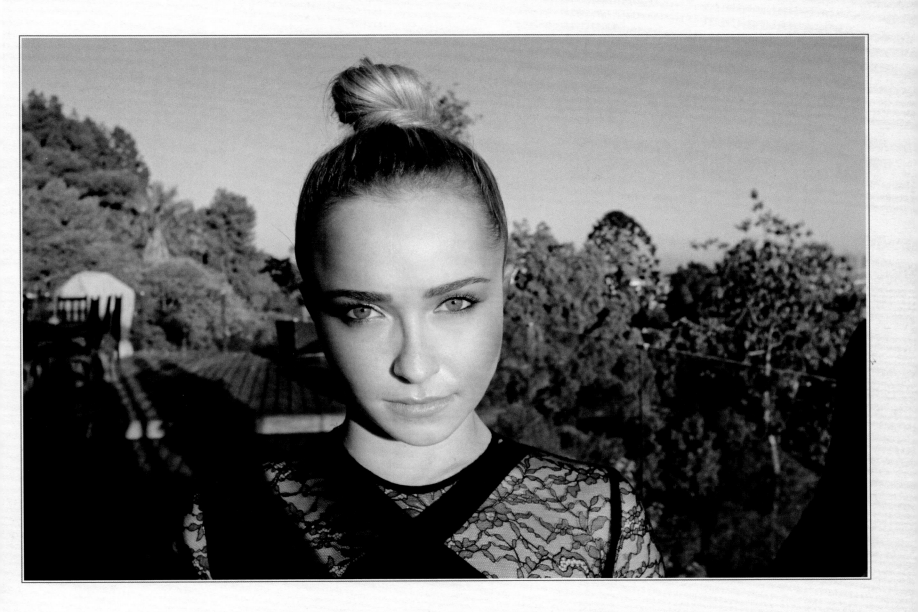

CHIP ESTEN

ACTOR, SINGER, COMEDIAN

ABOVE: Chip Esten, who plays Deacon Claybourne on ABC's *Nashville*, with co-star Hayden Panettiere at Edgefield Sports Bar & Grill in Nashville. OPPOSITE: Esten with songwriter Emily Shackelton at The Bluebird Cafe.

SINCE THE MOMENT I ARRIVED here to play Deacon Claybourne in the show bearing this great city's name, I've been bombarded and blessed by a series of moments that are, honestly, still very hard for me to believe. I've been part of fantastically written scenes with incredible castmates, in locations all across Nashville. I've been allowed to perform music in the very best of Music City's iconic venues. From my first writers' rounds at the Bluebird Cafe (as Deacon, and then as myself) to my first appearances at the historic Ryman Auditorium and the Grand Ole Opry (once again, first as Deacon, then as myself), it's become clear that I've slipped through some kind of mystical side door to Nashville nirvana.

See, Nashville isn't just a "dream come true" for me. It's a whole bunch of "dreams come true." And all that I can say about these many unbelievably moving moments is that I am deeply grateful and take none of them for granted on any level. Every single day, I thank God for this city, and for the life it's given my family and me.

Okay, fine. But what's my *favorite* Nashville moment?

Here it is. With a bit of backstory.

My youngest daughter is named Addie. When she was two years old, she exhibited a series of physical symptoms that had my wife and me worried. A trip to Cedars-Sinai and a series of tests later, we were given the doctor's diagnosis: acute lymphoblastic leukemia.

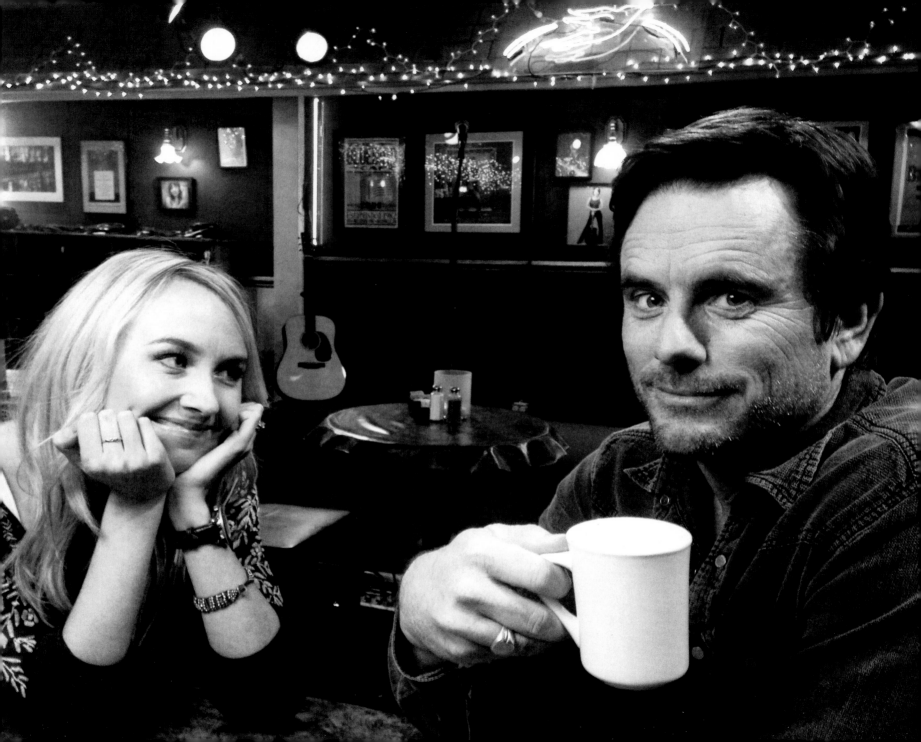

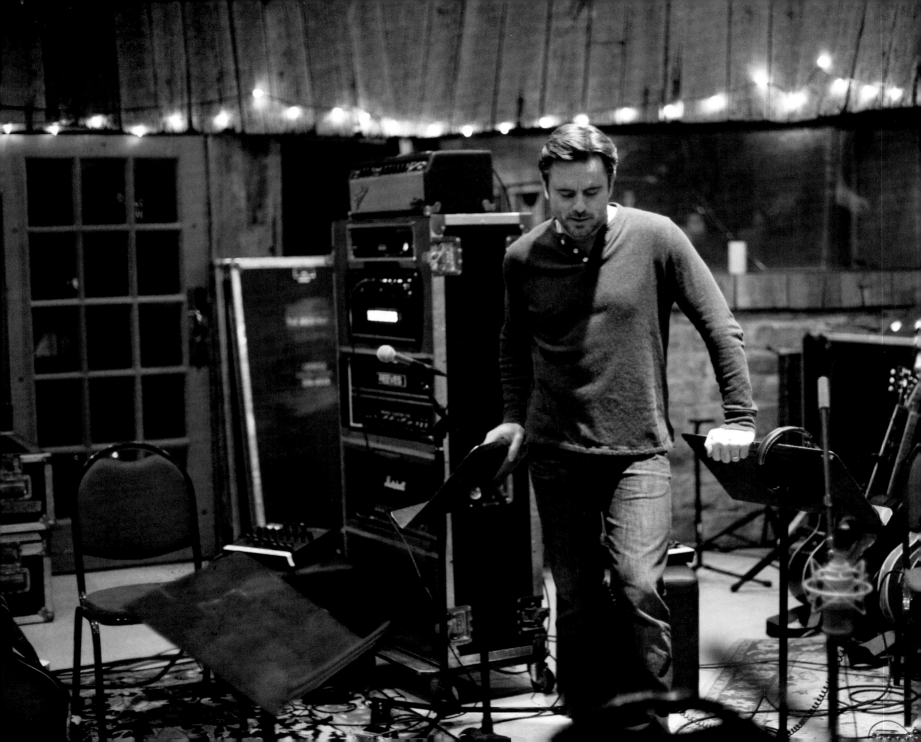

We were devastated. But that doctor also brought us words of hope: 85 percent survival rates for kids Addie's age; protocols and chemo-therapies that could bring her back to good health and a good life. That was the prayer and the goal for the two years we walked that difficult path with our tough little girl and her very supportive older brother and sister.

Today, she is a beautiful, happy, healthy fifteen year old. She's an honor student and a Tennessee state champion club soccer player. She is kind and loving and—thank God—she is cancer-free.

So what does that wonderfully happy ending have to do with my favorite Nashville moment? This: When I was a kid, childhood leukemia was a virtual death sentence. It was research that changed that. Lots and lots of research. And it was fund-raising that made that research possible. Early in Addie's journey, my wife and I found out about the Leukemia and Lymphoma Society (LLS) and all they had done to fight blood cancers. As Addie got healthier, we became more and more involved in the Los Angeles chapter. But it wasn't until we came to Nashville and this fantastic local chapter that we truly became involved. In October 2013, we walked in our first Light the Night walk to raise money for LLS.

We walked that night in a massive parade that began right outside LP Field. We were surrounded by about six thousand fund-raisers on various fund-raising teams, each carrying illuminated balloons—white for survivors, red for supporters, and gold in memory of those who had not survived their battle. As we all crossed the Korean Veterans Memorial Bridge with balloons held high, I could see that amazing Nashville skyline. And I could see my family and our team and our smiling, healthy Addie

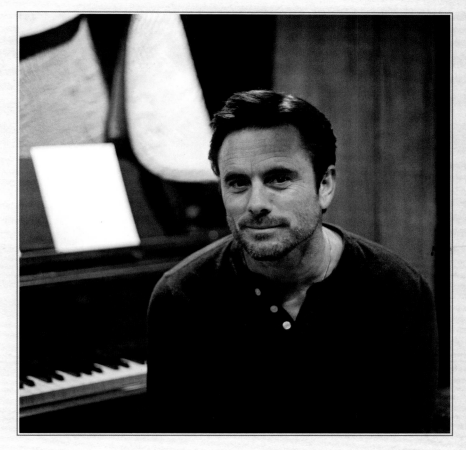

holding her beautiful white balloon. It's hard to describe how that felt. I was filled with joy and wonder and gratitude for the way my family had been blessed in the ten-year journey that took us from that dark diagnosis to a Nashville night filled with lights.

And that is my favorite Nashville moment.—**CHIP ESTEN**

THESE PAGES: Recording at Sound Emporium, one of Nashville's most legendary studios.

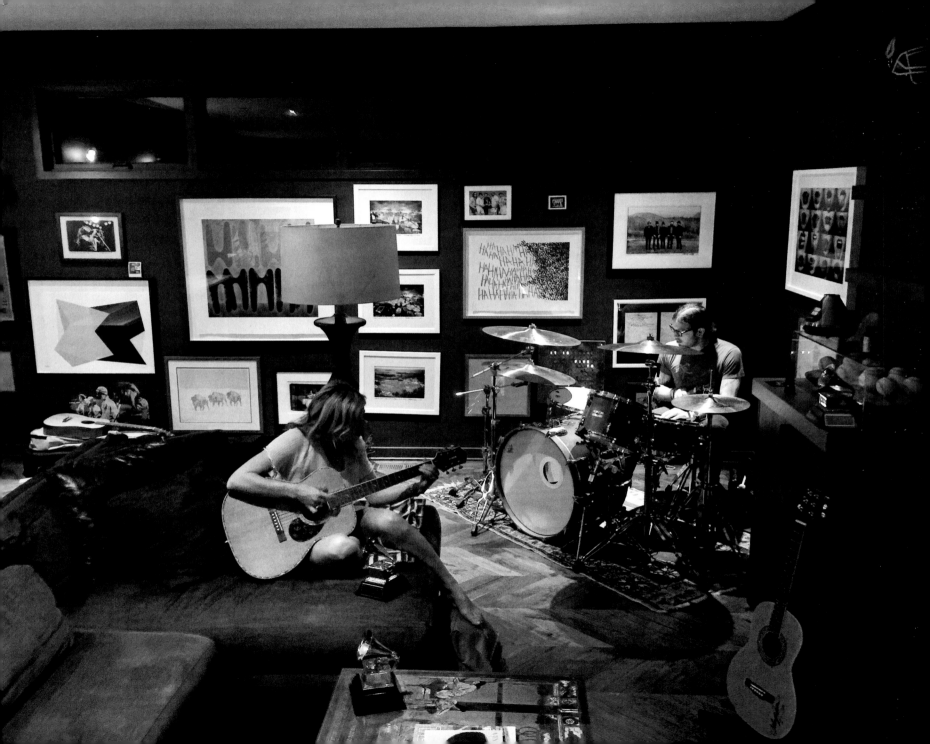

NATHAN FOLLOWILL AND JESSIE BAYLIN

KINGS OF LEON (NATHAN)
SINGER, SONGWRITER (JESSIE)

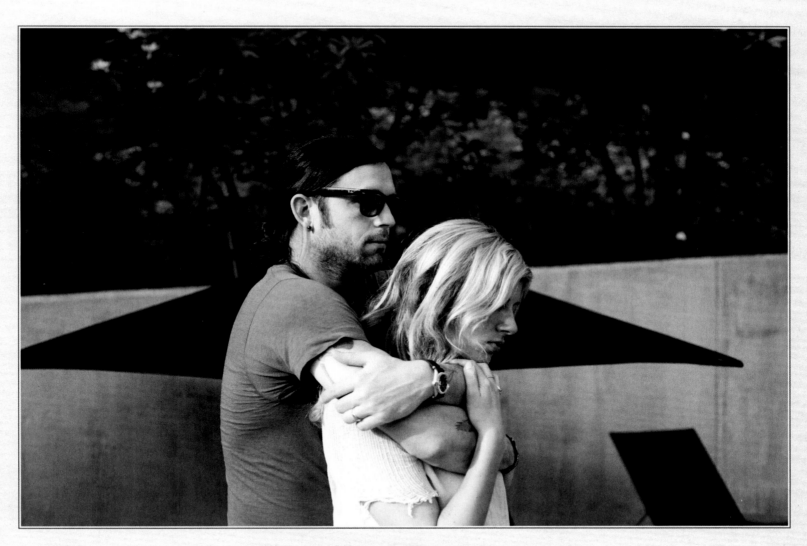

OPPOSITE: Followill and Baylin in Followill's man cave. PAGES 41–47: Nathan, Jessie, and daughter, Violet, at their home in Nashville, a mid-century modern house that friend Connie Britton lovingly nicknamed "Spa-llowill" after its serene atmosphere.

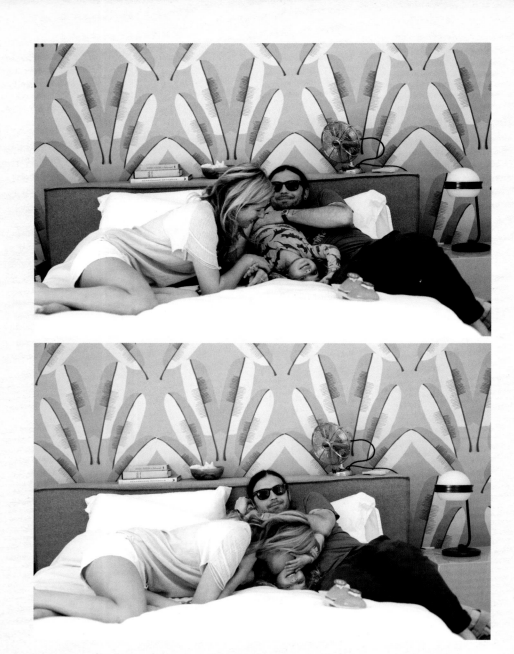

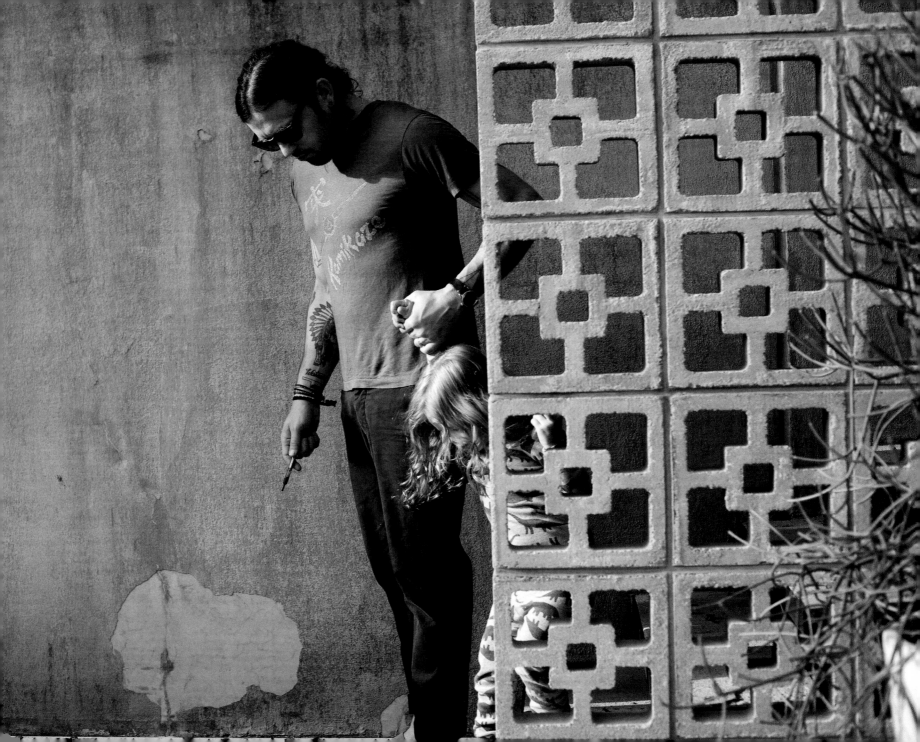

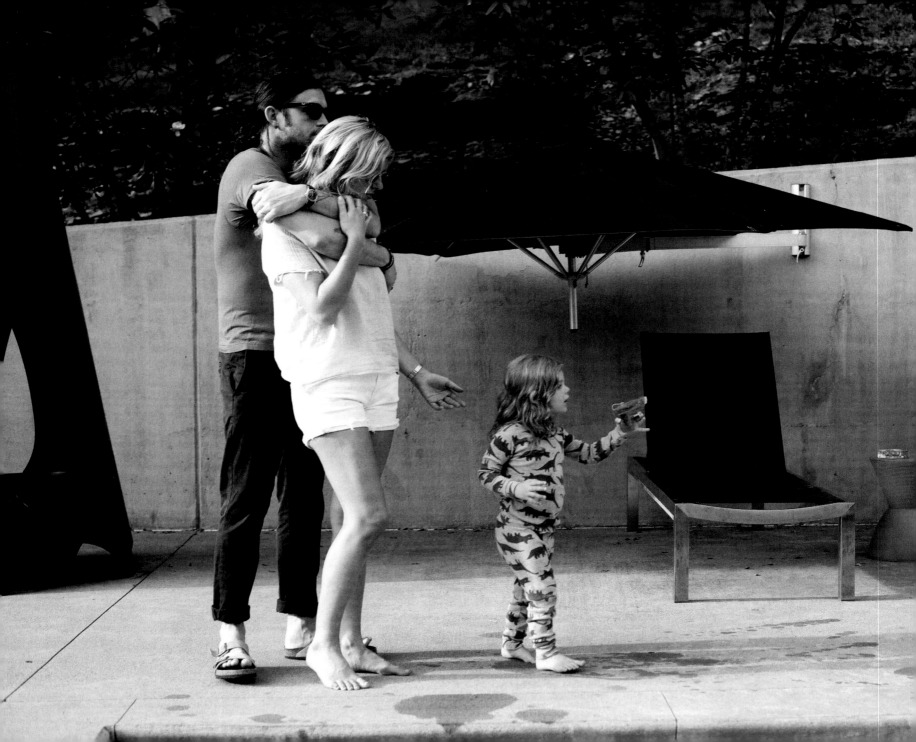

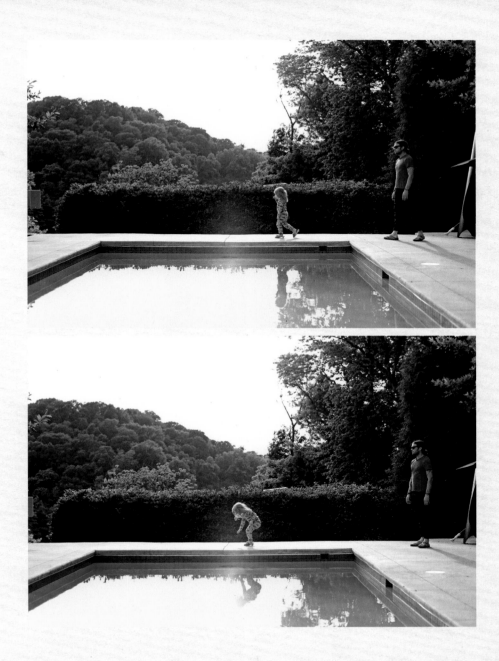

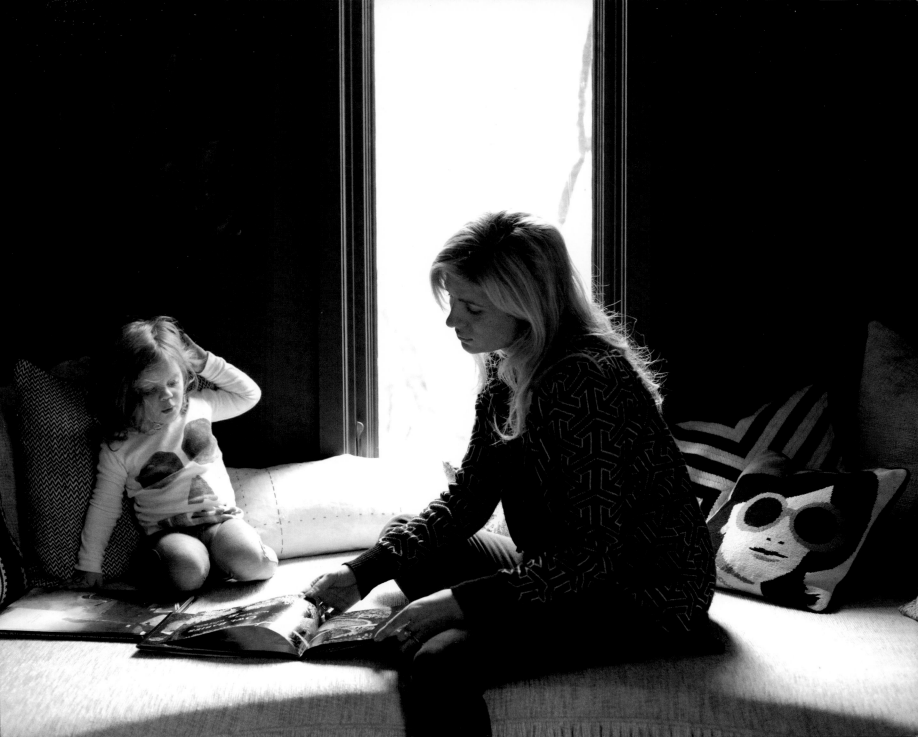

CONNIE BRITTON
ACTRESS, SINGER, PRODUCER

"You can't get too big or be too small in Nashville, because you will always be held in perspective by this surprising landscape. There will always be a bug or a bird to remind you that you're not alone and you're not in charge."

—CONNIE BRITTON

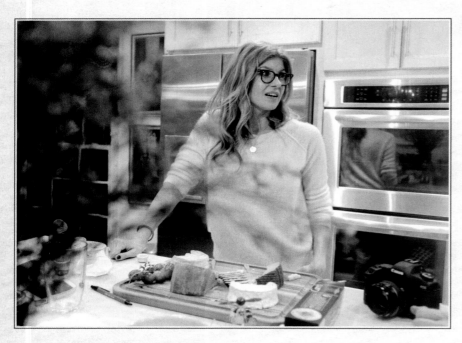

ABOVE: Actress Connie Britton, who plays country superstar Rayna James on ABC's *Nashville*. PAGES 49–51: Quiet moments at home with her son, Yoby.

I GREW UP IN VIRGINIA and when I came to Nashville I didn't know a soul. Well, that's not true. I knew Jessie Baylin and Nathan Followill, who have become some of the best friends anyone could have on the planet. So I could just stop right there if I wanted to, about Nashville's best. Done.

But if I wanted to keep going—I'll probably keep going—I'd talk about the trees and the forests, the mountains and crazy wilds of Nashville. That's right. When I first got here, everything was unfamiliar. It was a total upheaval. I was a new mother, I was working on a new show with long hours, and my support system was far, far away. But I'll never forget driving to record my first song ever, full of terror and exhilaration, while recording the pilot of *Nashville*, and looking out the window on my way to Ross Copperman's studio, which at that time seemed to be, from what I knew, "outside of town."

As we drove to what felt like the gallows (the studio), the road gradually turned from businesses and restaurants to just trees, just green. I remember a sense of calm coming over me—a completely visceral memory of childhood in the South, in the Blue Ridge Mountains of Virginia, along with occasional visits to grandparents in the Smoky Mountains of North Carolina. I swear, in that moment, the comforts of home washed over me and helped me get through my recording. Ross's little airplane bottle of whiskey didn't hurt, either.

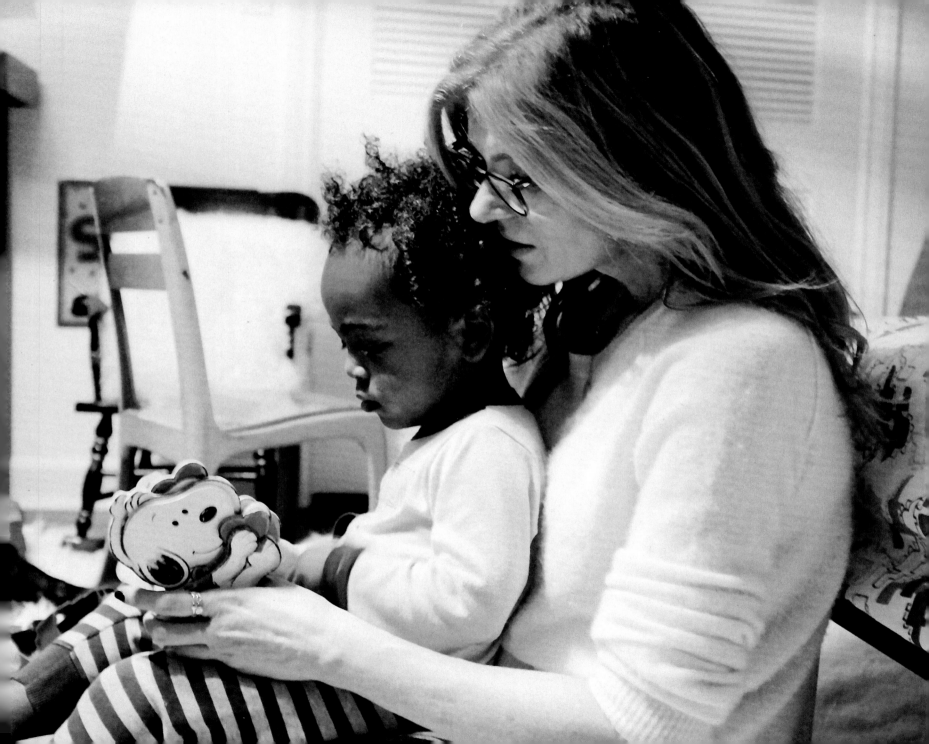

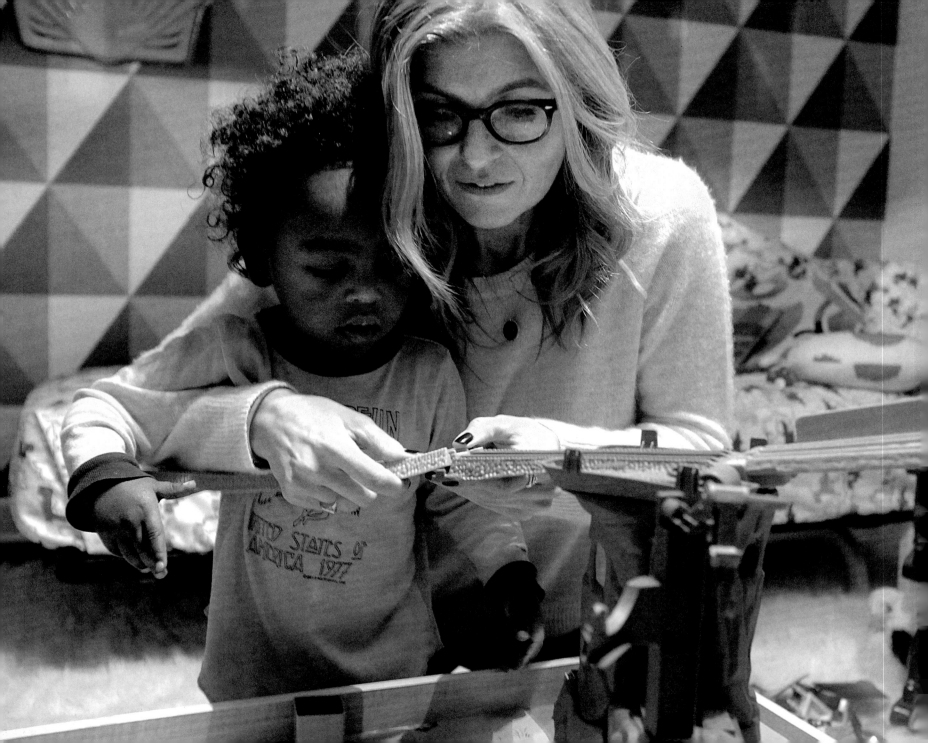

There's something about the southeastern landscape—the abundance of nature and the carefree magnitude of the mountains and hills—that's unmistakable. There's nothing quite like it in the world. I didn't realize this until I'd been gone for a long time (in New York and Los Angeles), only to come back and rediscover it in a town where I didn't expect it—a town that is, in its own right, a relatively sophisticated city. Here we have mountains and lakes and creeks that feel solid, historical, unyielding, and utterly generous. This is a town full of creativity and kindness, busyness and business, innovation and tradition. And all of that happens in the midst of this relentless nature. You can't get too big or be too small in Nashville, because you will always be held in perspective by this surprising landscape. There will always be a bug or a bird to remind you that you're not alone and you're not in charge. I could list all the beautiful places I love to visit to enjoy the beauty of this place, but I'd just get confused and end up saying "my backyard."

Home. Thanks to you, beautiful town in the midst of something much larger. I'll stop and leave it up to Walt Whitman: "I believe a leaf of grass is no less than the journey-work of the stars." Truer words could never be spoken about Nashville, Tennessee.—**CONNIE BRITTON**

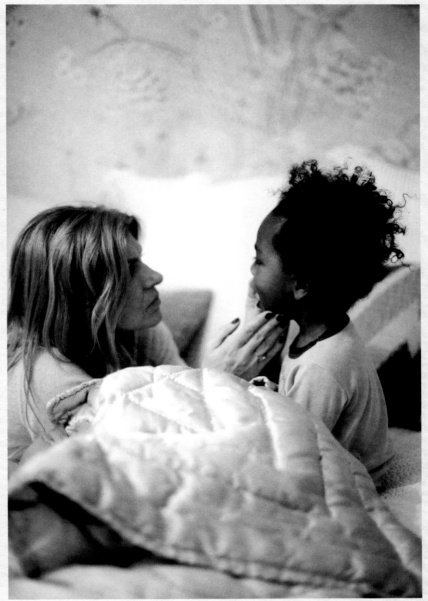

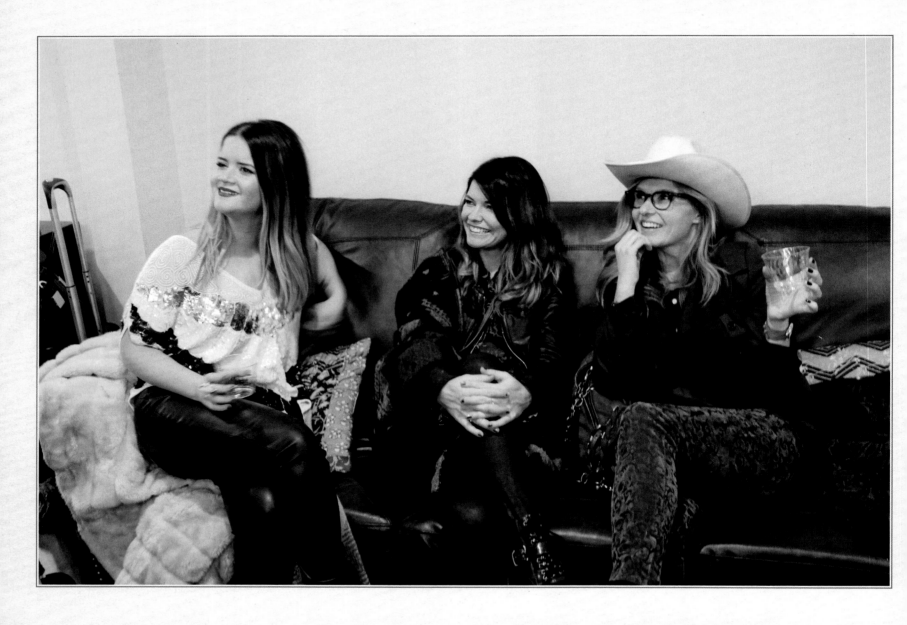

THESE PAGES: Backstage moments with Maren Morris, Erin McCarley, and Kree Harrison. FOLLOWING PAGES: Maren Morris backstage at the City Winery, opening for Steve Moakler; Morris at home in Nashville.

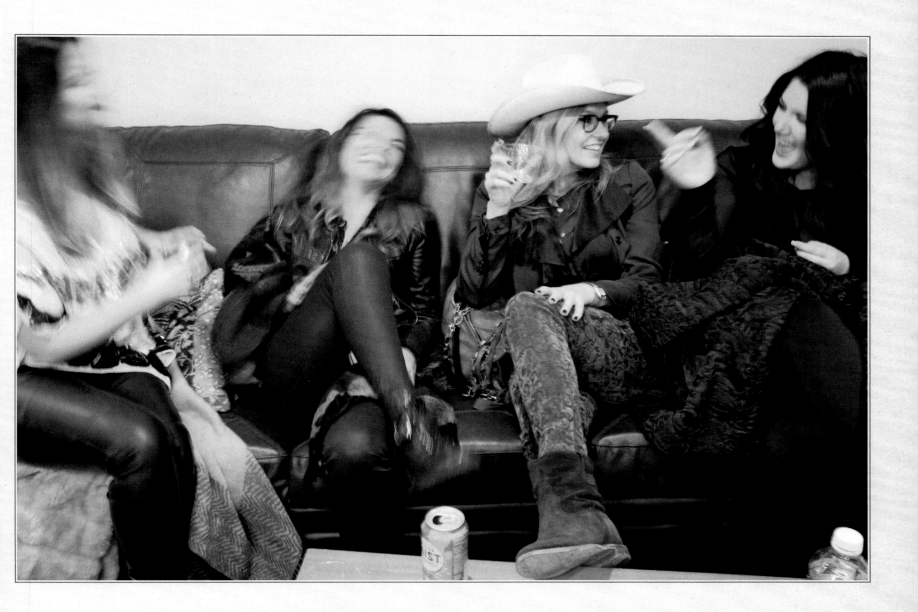

MAREN MORRIS
SINGER, SONGWRITER

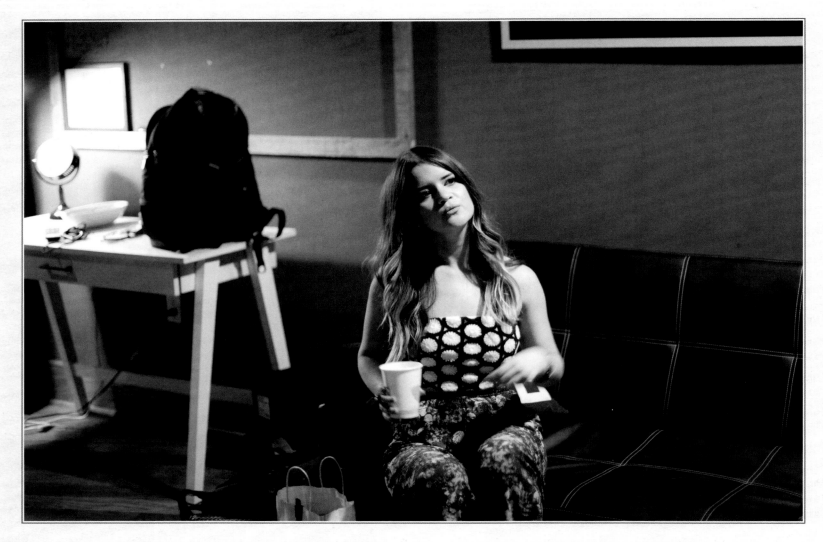

"You write so many songs a year in this town and never hear a peep about them, but when one actually gets through the noise, you're left in disbelief and utter gratitude."—MAREN MORRIS

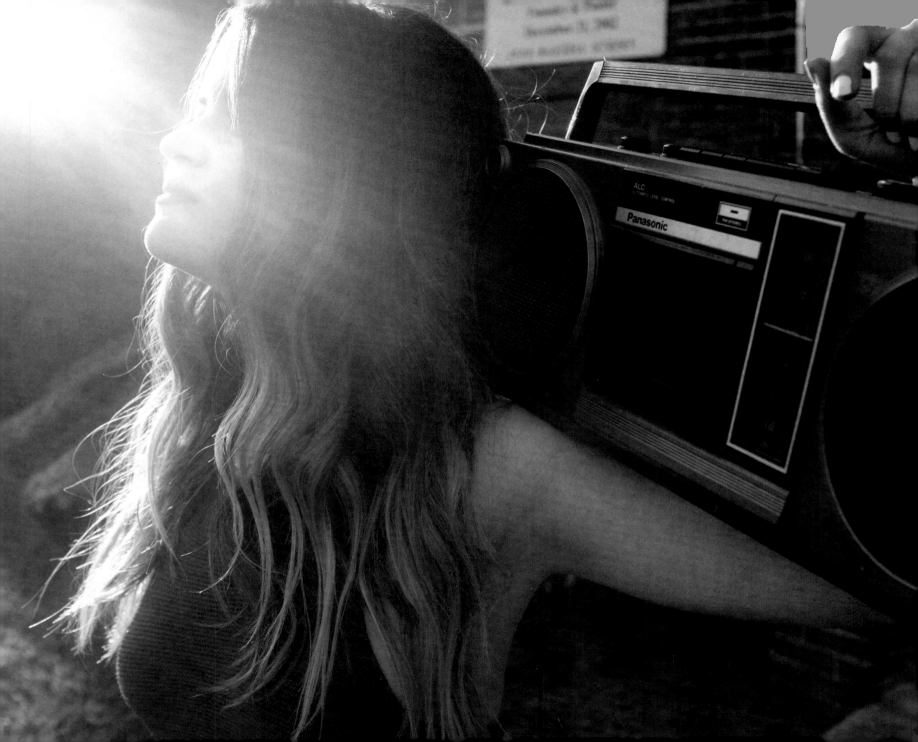

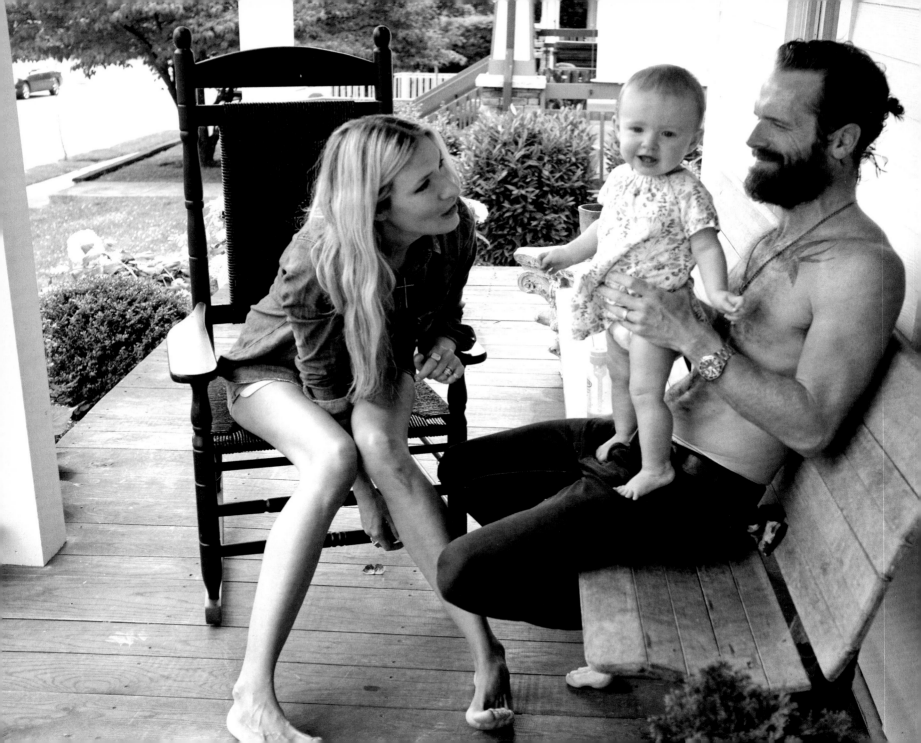

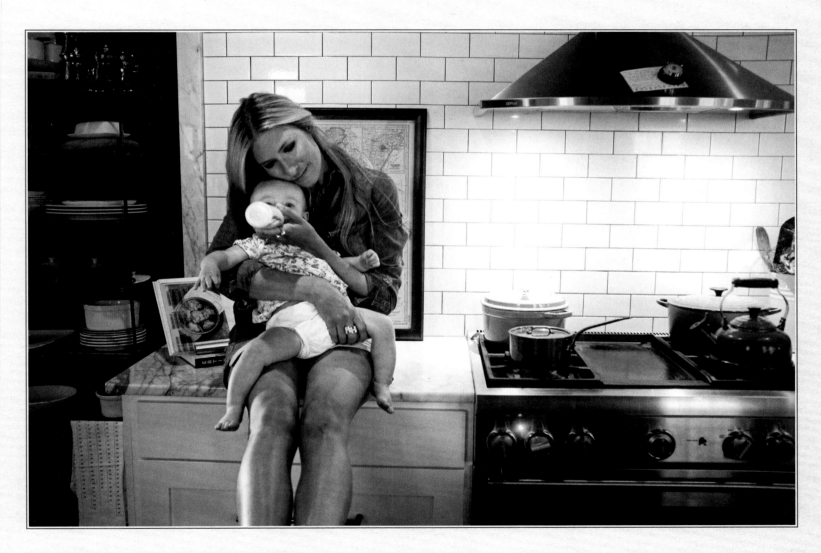

THESE PAGES: Holly Williams, granddaughter of Hank Williams Sr.,
with her husband, musician Chris Coleman, and daughter, Stella June.

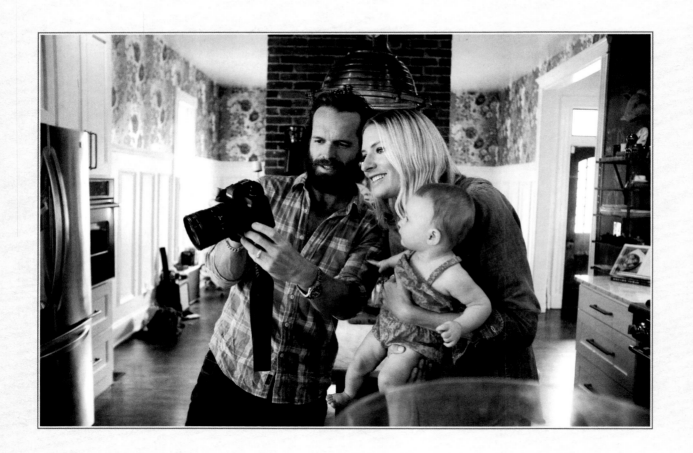

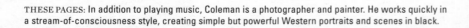
THESE PAGES: In addition to playing music, Coleman is a photographer and painter. He works quickly in a stream-of-consciousness style, creating simple but powerful Western portraits and scenes in black.

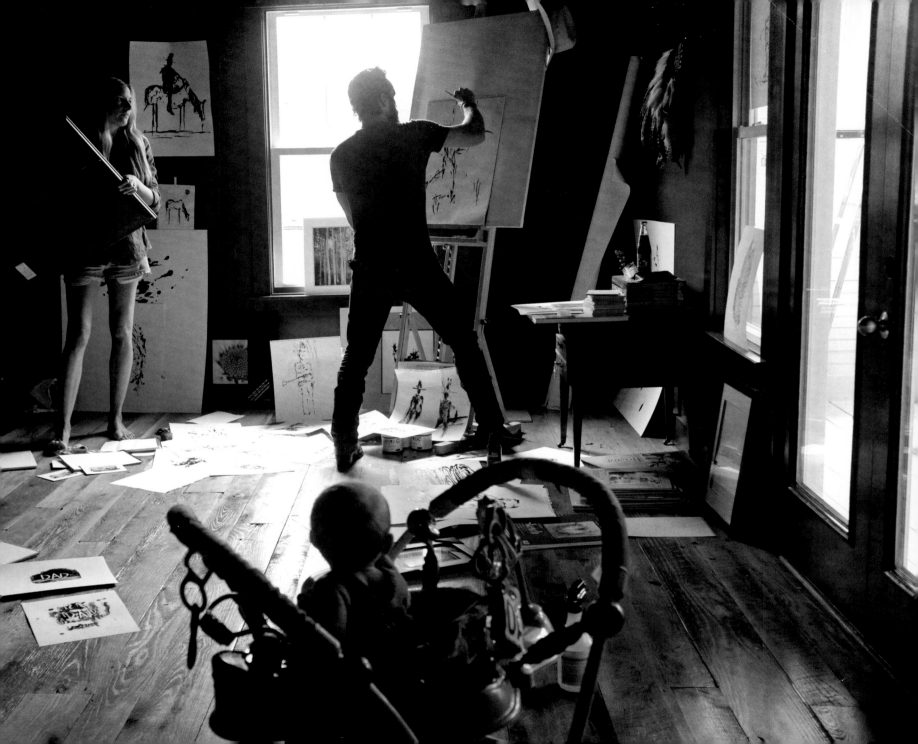

CLARE BOWEN

ACTRESS, SINGER

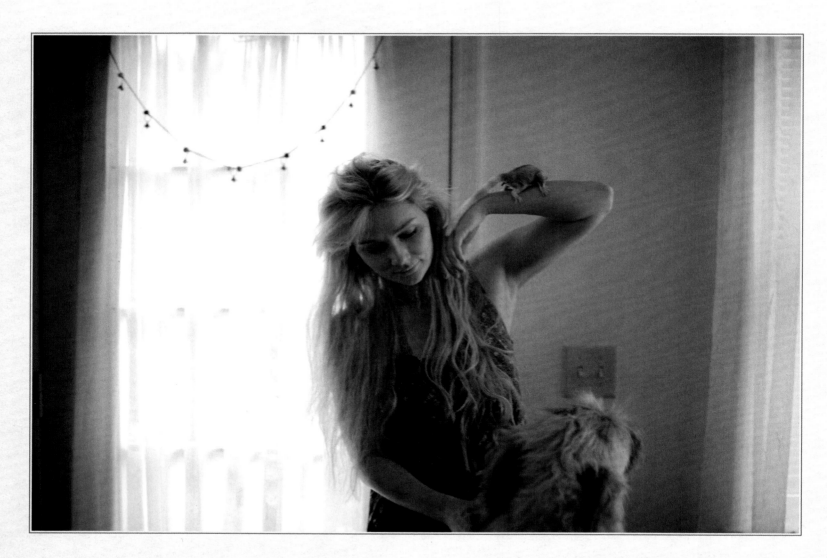

THESE PAGES: Clare Bowen, who plays Scarlett O'Connor on *Nashville*, surrounded by her pets in the early morning before a piano lesson.

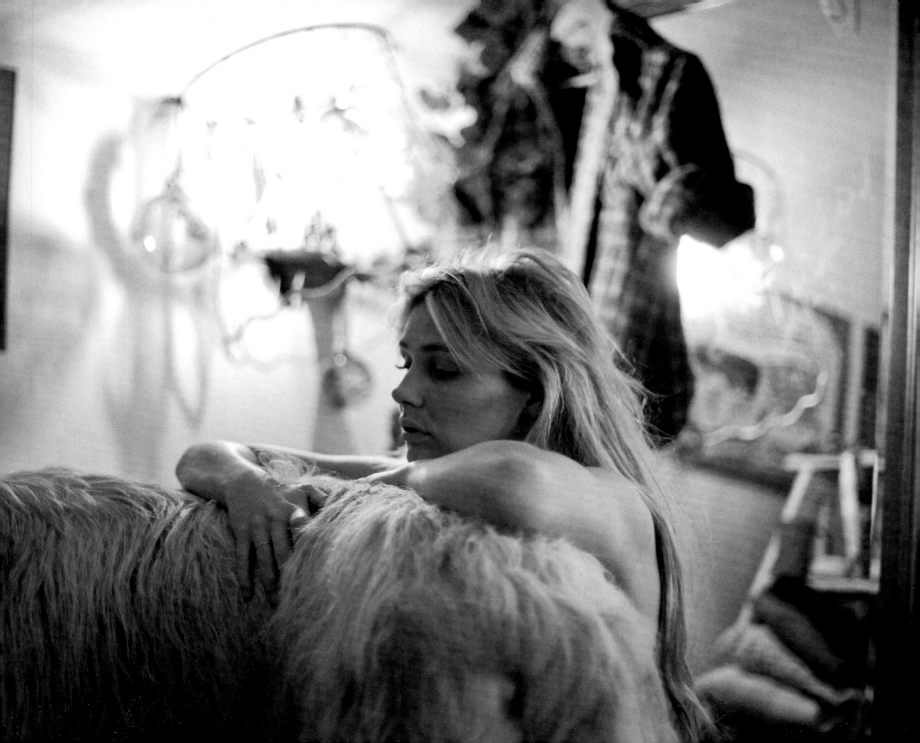

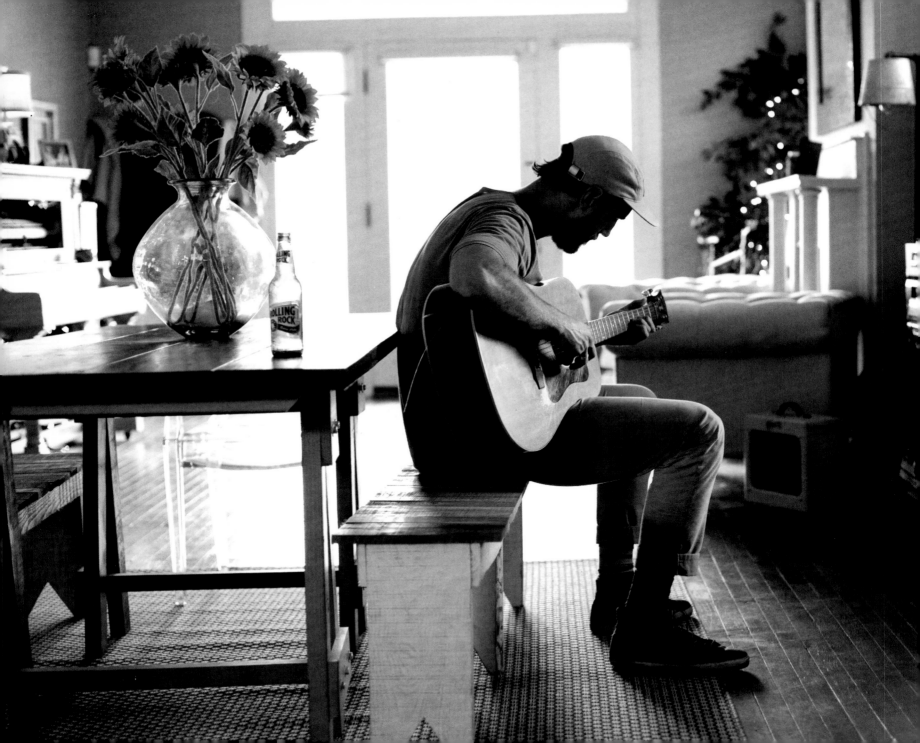

"Nashville has always been my home. I was born here.

Maybe I'll die here, if I don't live forever."—RAYLAND BAXTER

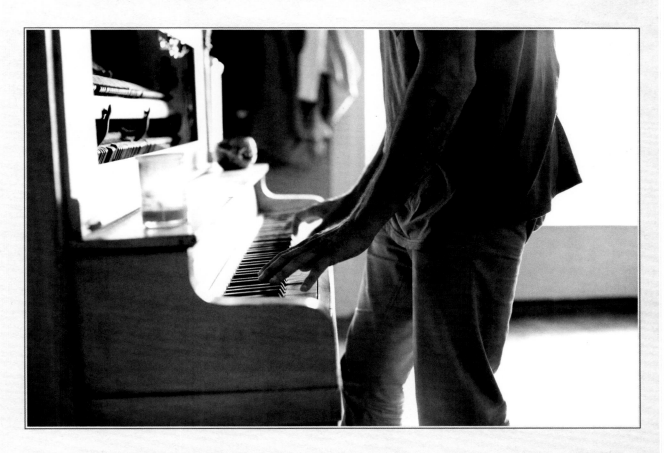

THESE PAGES: Rayland Baxter at John Osborne and Lucie Silvas's house in East Nashville. Baxter grew up in Nashville, the son of pedal steel legend Bucky Baxter.

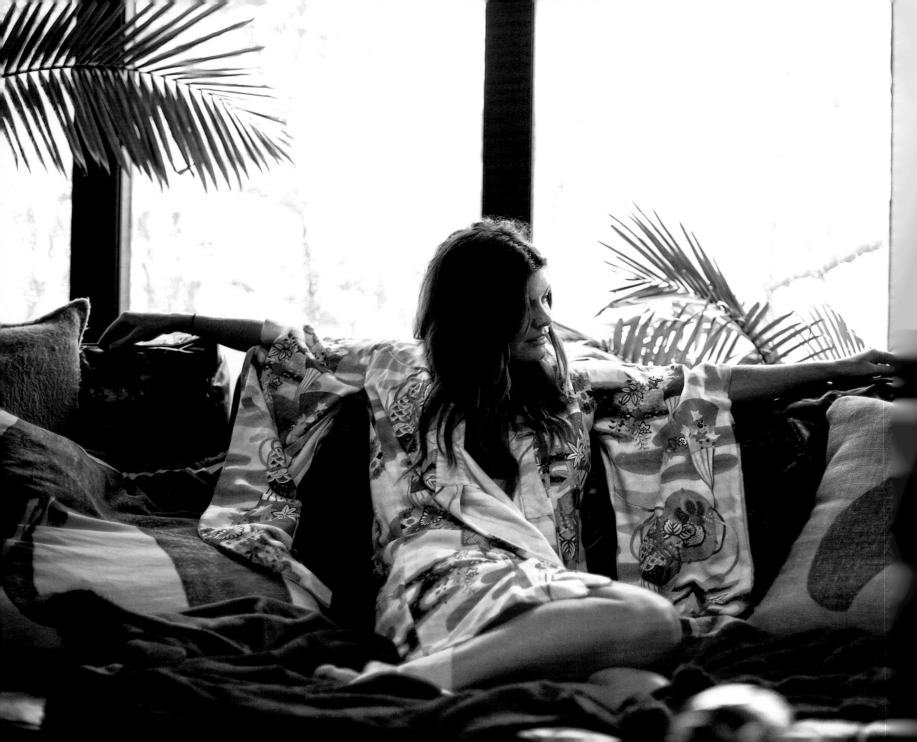

ERIN McCARLEY AND K.S. RHOADS

SINGER, SONGWRITER (ERIN)
WRITER, PRODUCER, SINGER (K.S.)

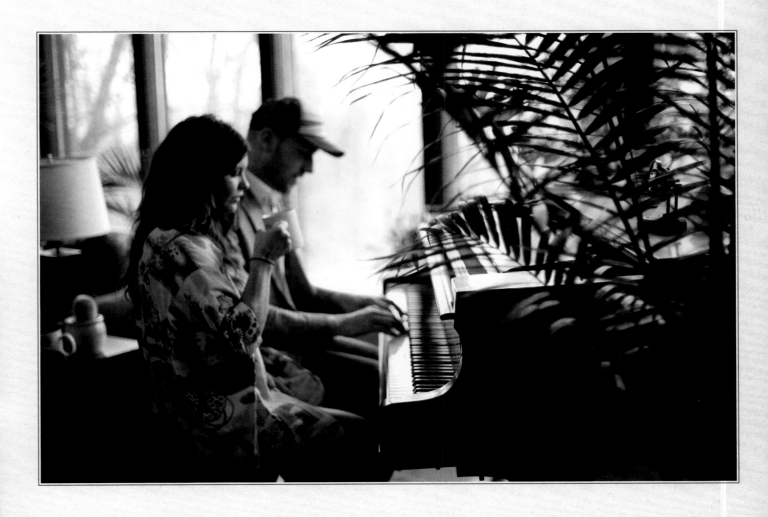

THESE AND FOLLOWING PAGES: Erin McCarley and husband, K.S. Rhoads, at their home in Brentwood, just outside of Nashville. Both accomplished musicians in their own right, the husband-and-wife duo are frequent collaborators.

"The virtue of the song is the key to the heart of Nashville."—ERIN McCARLEY

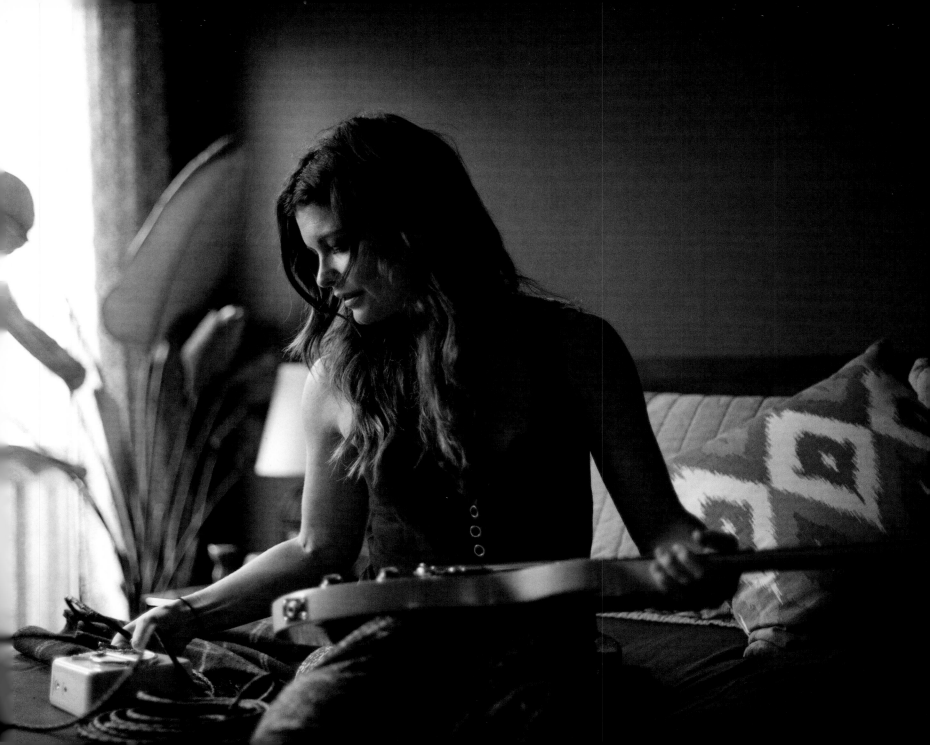

EMILY WEST

MUSICAL ARTIST

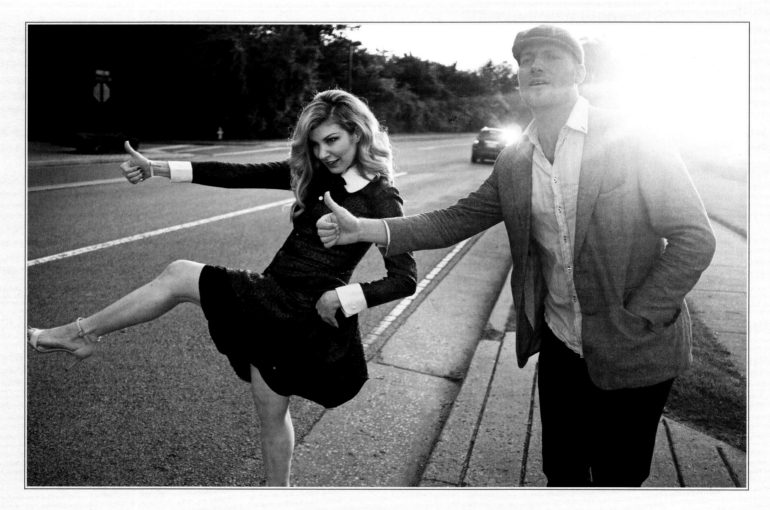

"Nashville is a place for the unhappy and romantic. It's a fairytale out here."—EMILY WEST

THESE PAGES: *America's Got Talent* runner-up Emily West with K.S. Rhoads before a show at The Factory in Franklin, Tennessee.

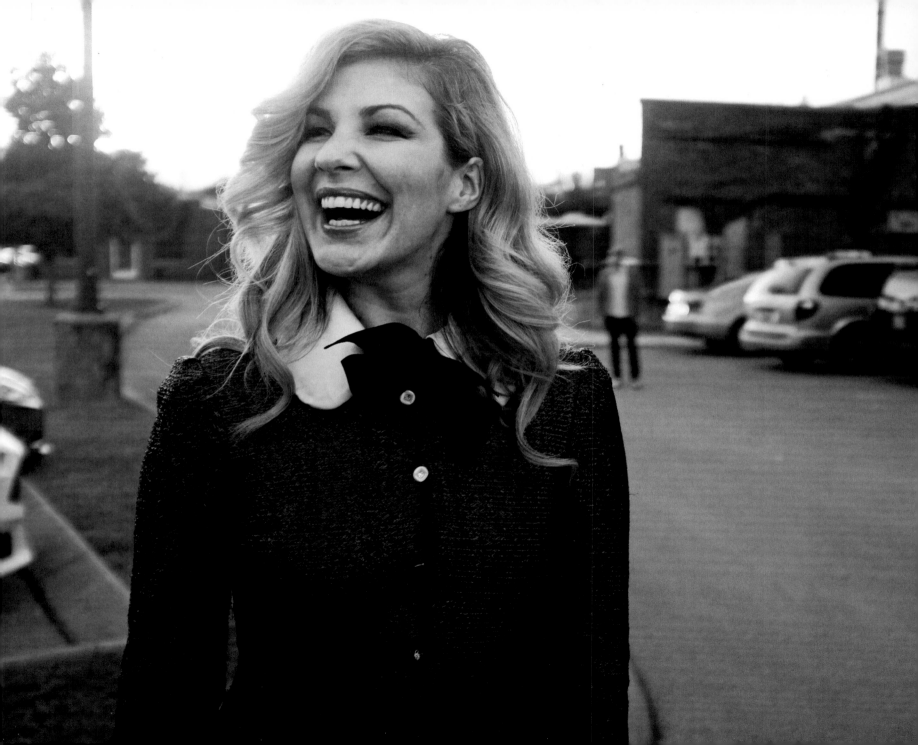

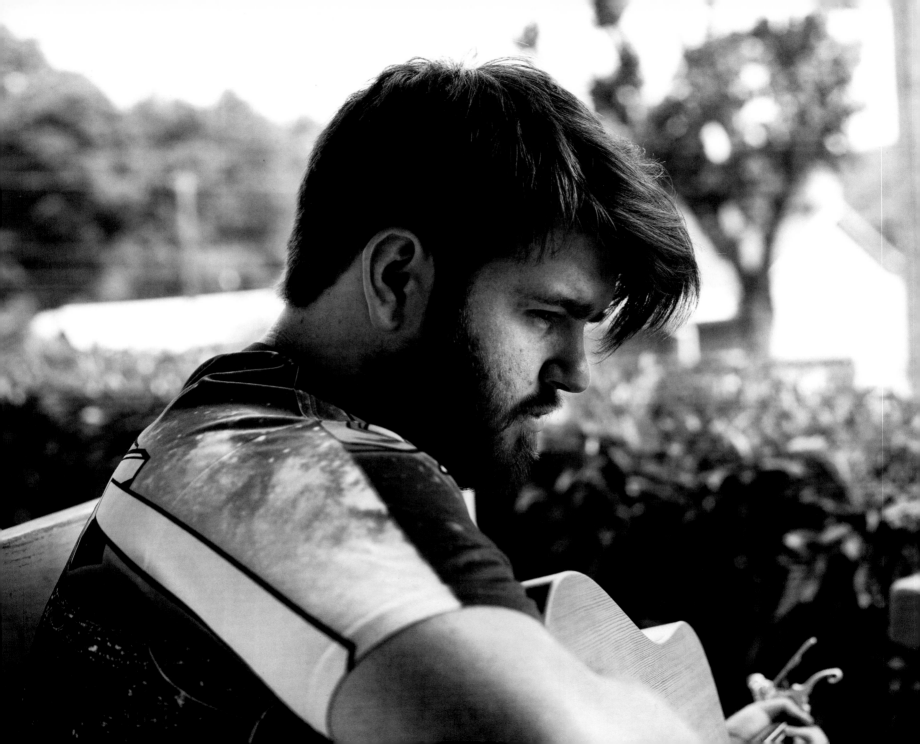

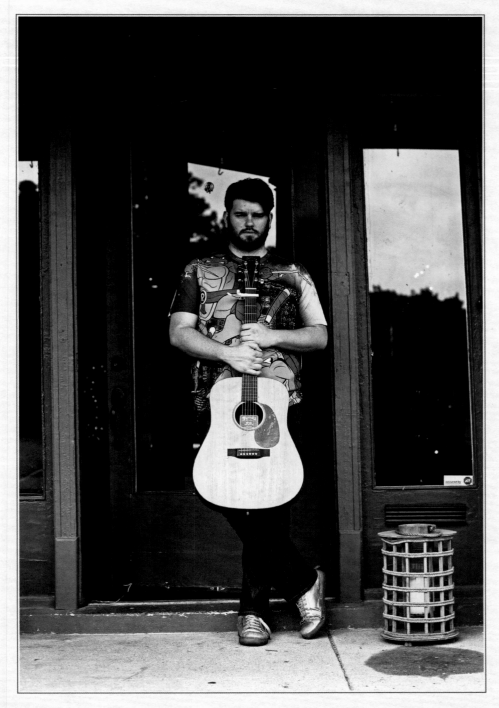

WHO IS FANCY
SINGER, SONGWRITER, MUSICIAN

"I was seventeen when I moved to Nashville. I dropped out of high school, got my license, got the hell out of Arkansas. I had barely driven on a highway until the day I left. I remember the pulse I felt first driving into town. Nashville has its own rhythm. It was new and nostalgic all at once. I still feel that every time I am back in Nashville. That's what makes it home."—JAKE HAGOOD

THESE PAGES: Jake Hagood, aka Who Is Fancy, rehearsing at Lucie Silvas's house prior to a show at the High Watt.

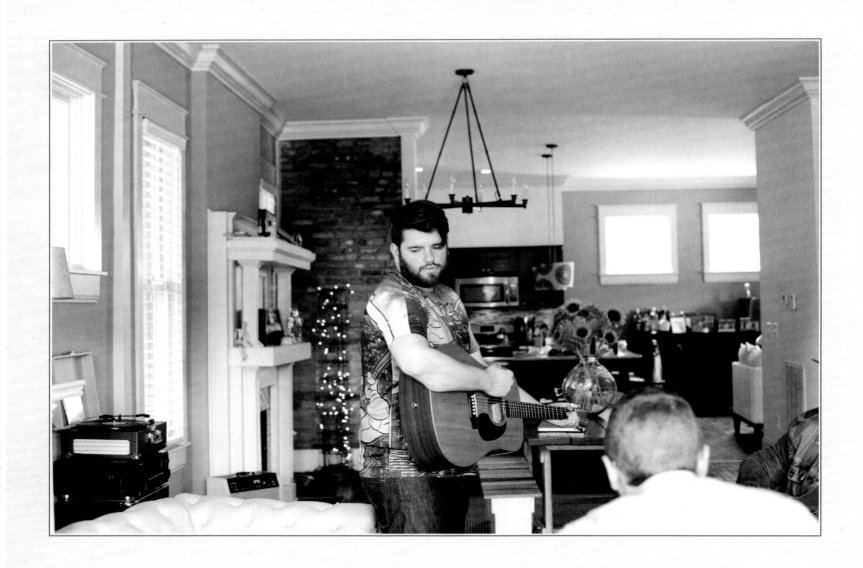

THESE PAGES: A well-known local presence in Nasvhille, Hagood revealed himself to be the voice behind the pop anthem "Goodbye" on Jimmy Fallon's *The Tonight Show* in April 2015.

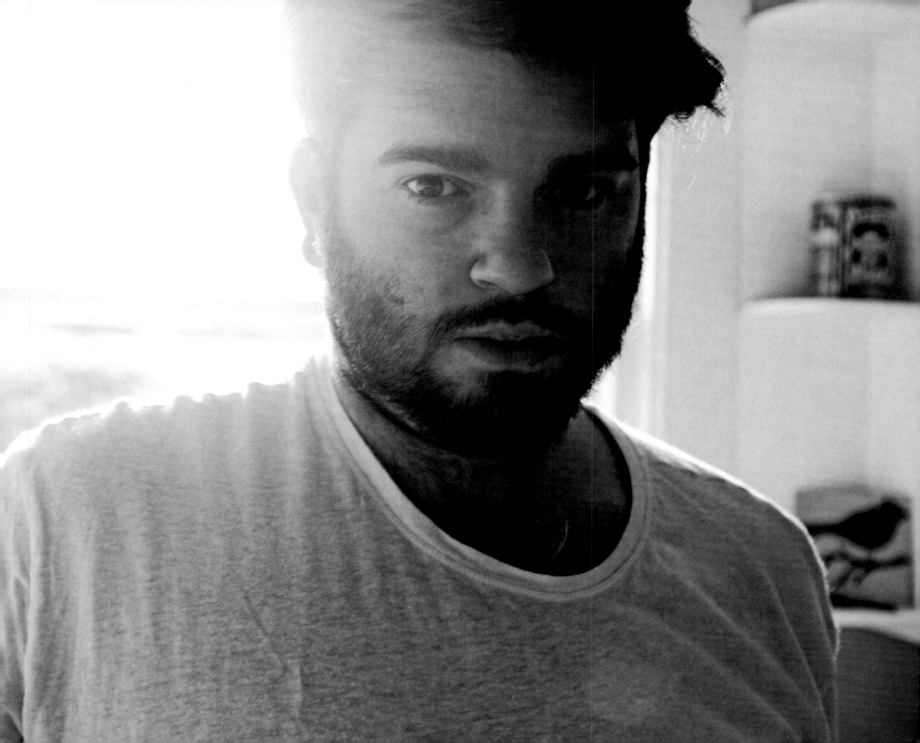

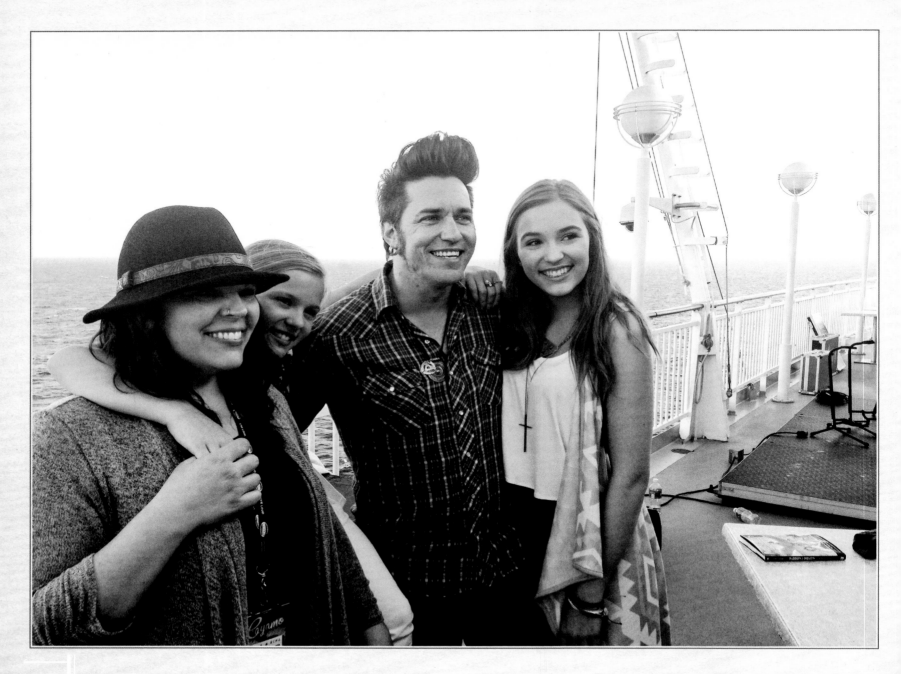

LENNON & MAISY

ACTRESS, SINGER (LENNON)
ACTRESS, SINGER (MAISY)

THESE PAGES: Canadian-born Lennon Ray Louise and Maisy Jude Marion, the Stella Sisters, are known for their roles as Maddie and Daphne Conrad on ABC's *Nashville*. They also frequently perform with their parents' country music group, The Stellas.

BOB HARRIS
RADIO HOST

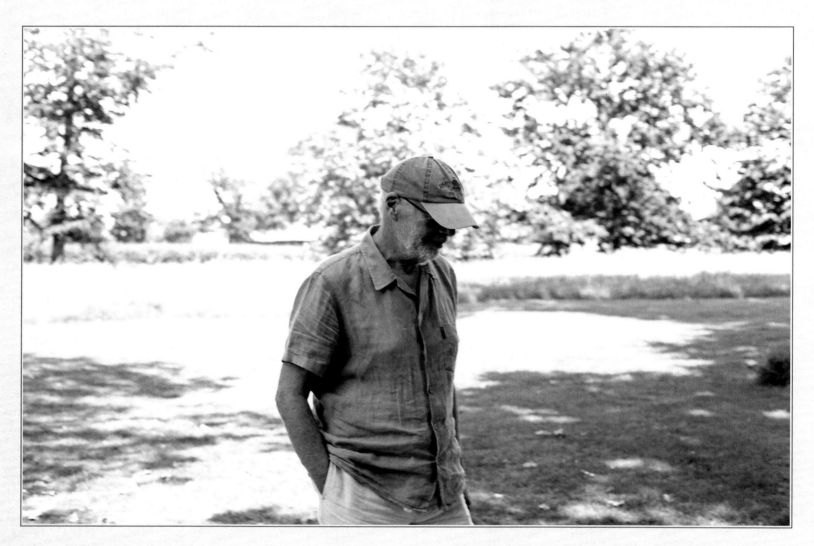

THESE PAGES: Dubbed "Whispering Bob Harris" for his hushed tones on the airwaves, Harris has been a tireless advocate and promoter of American country music abroad for over forty years.

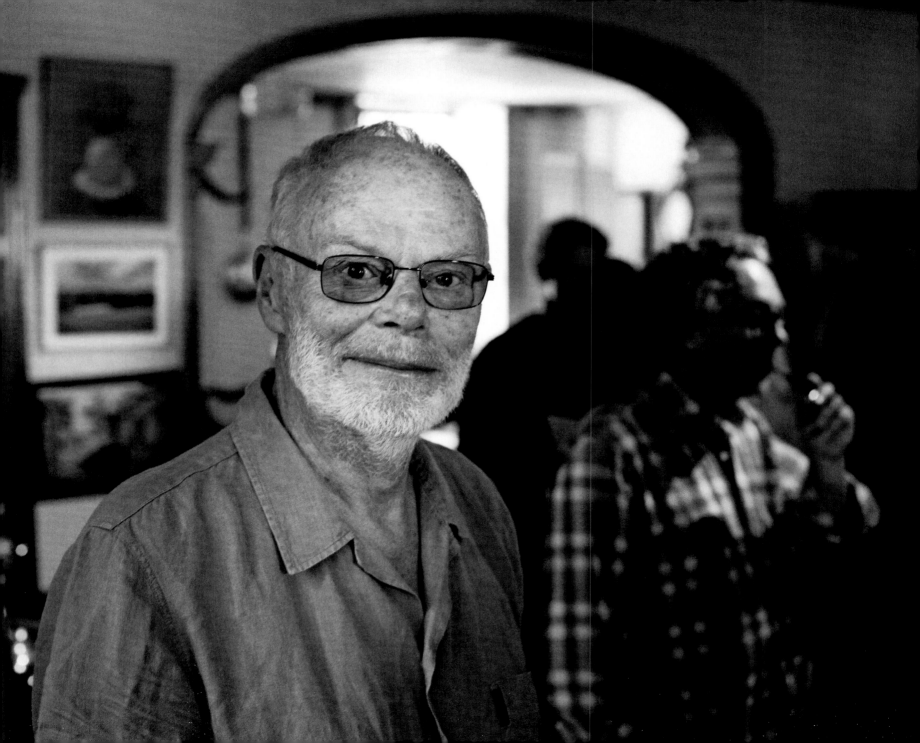

KACEY MUSGRAVES
SINGER, SONGWRITER

"I would have nothing without songs—songs that could have only been written in that time and space, under those circumstances, under that leaky roof on Shelby, and created with the gifted souls who make Nashville one of the most unique places in the world."—KACEY MUSGRAVES

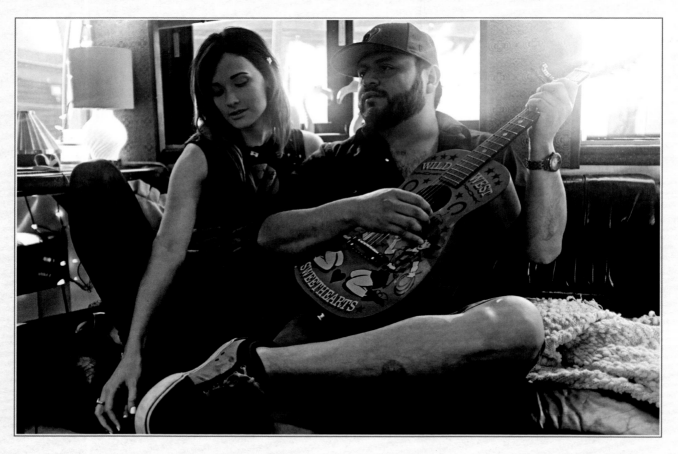

Kacey Musgraves, the voice behind the lauded albums *Pageant Material* and *Same Trailer, Different Park*, first gained recognition with an appearance on *Nashville Star.* ABOVE: Musgraves with Misa Arriaga on the tour bus. OPPOSITE: A quiet moment rehearsing backstage.

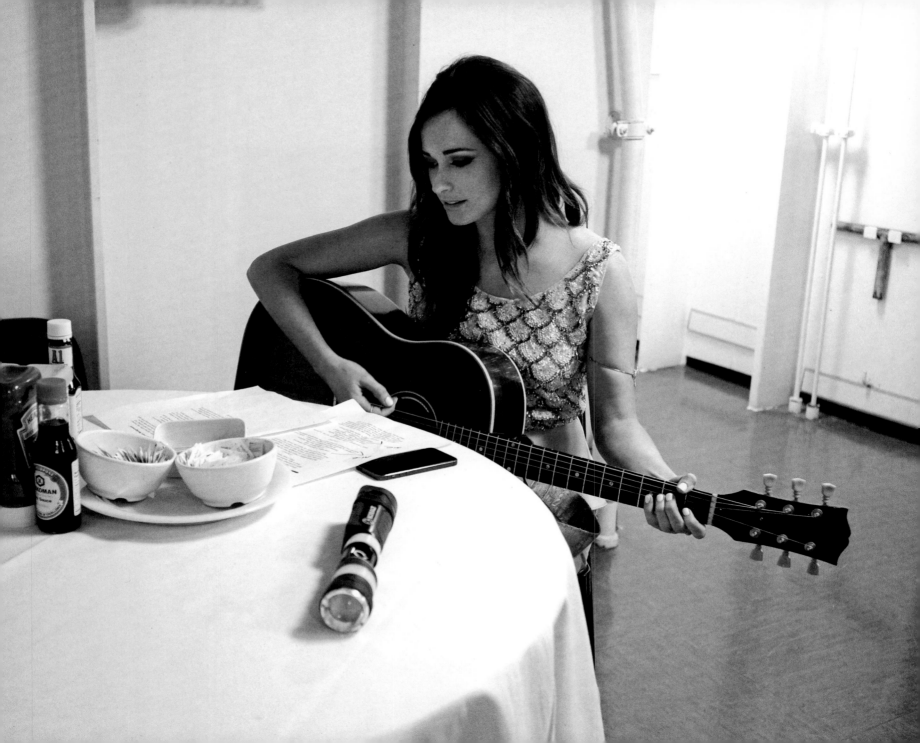

ABOVE: Before going onstage at the Glastonbury Festival in the United Kingdom. OPPOSITE: Backstage on the Cayamo Cruise.

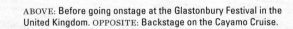

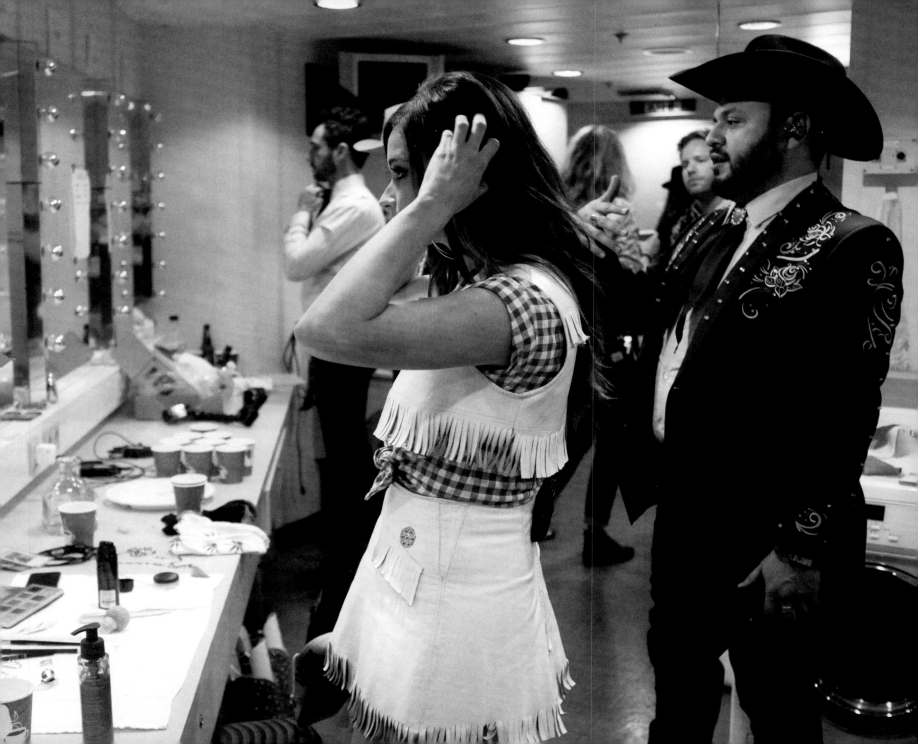

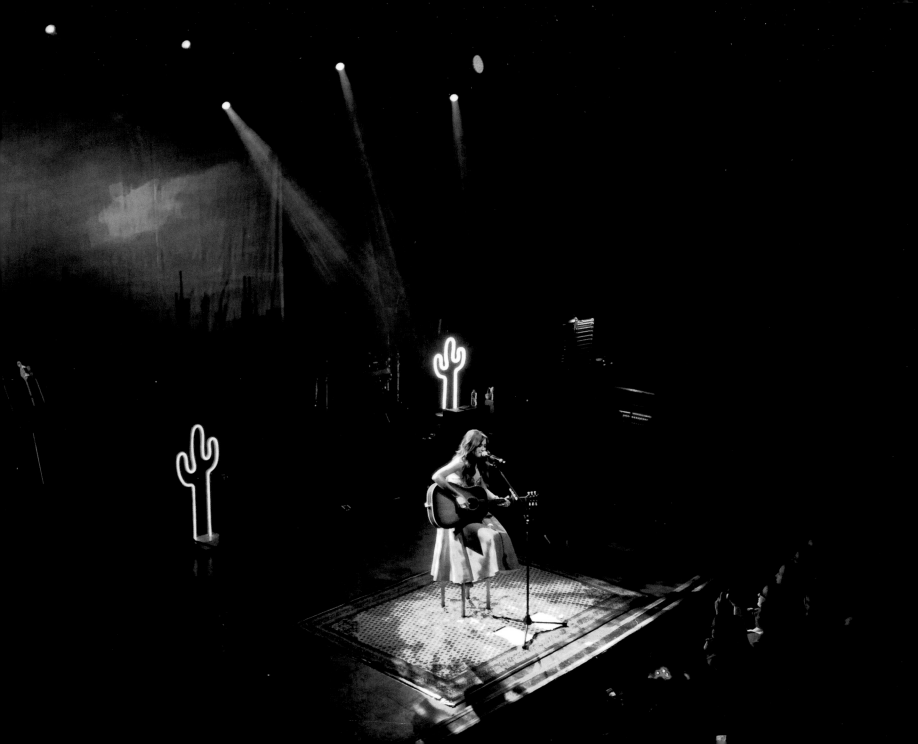

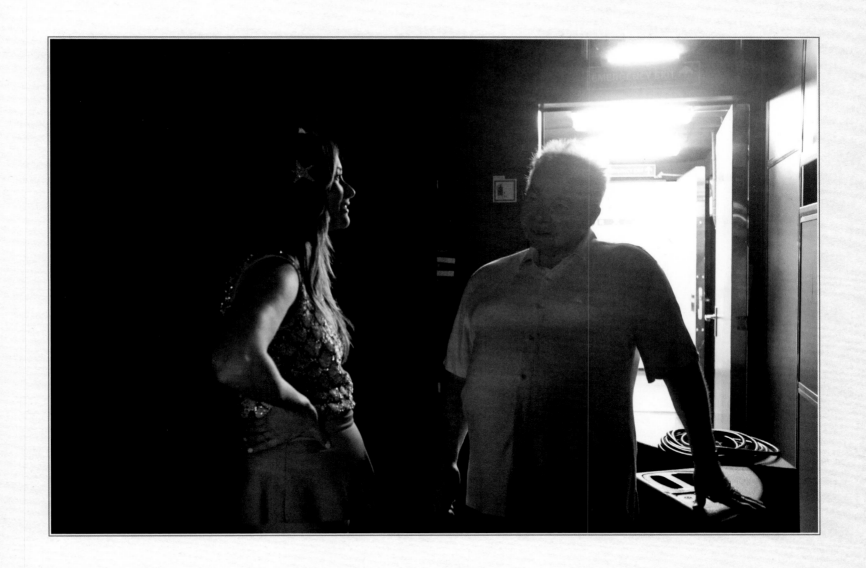

OPPOSITE: On stage at Shepherd's Bush Empire in London.
ABOVE: With John Prine on the Cayamo Cruise.

ABOVE: With Elice Cuff on Old Hickory Lake, outside Nashville. OPPOSITE: On tour.

SAM PALLADIO
ACTOR, MUSICIAN

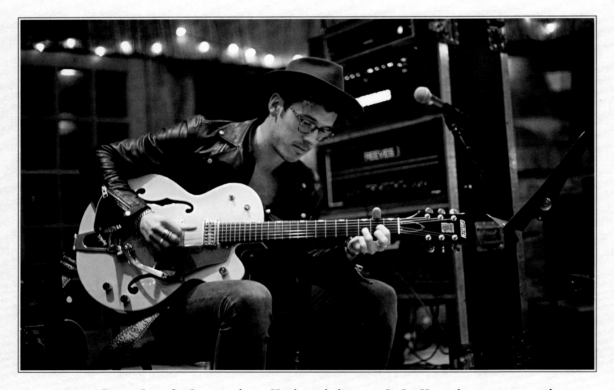

"It's a place that feels continually inspiring and challenging as an artist, a place with a creative and compassionate community. Having grown up by the sea in Cornwall in the UK, I never thought I'd find myself living in Tennessee, but I was so embraced by the people of the city, the Southern hospitality, and the music in the air, that I definitely felt at home."—SAM PALLADIO

THESE PAGES: British-born Sam Palladio recording at Sound Emporium Studios. Palladio plays the Texan songwriter Gunnar Scott on ABC's *Nashville*.

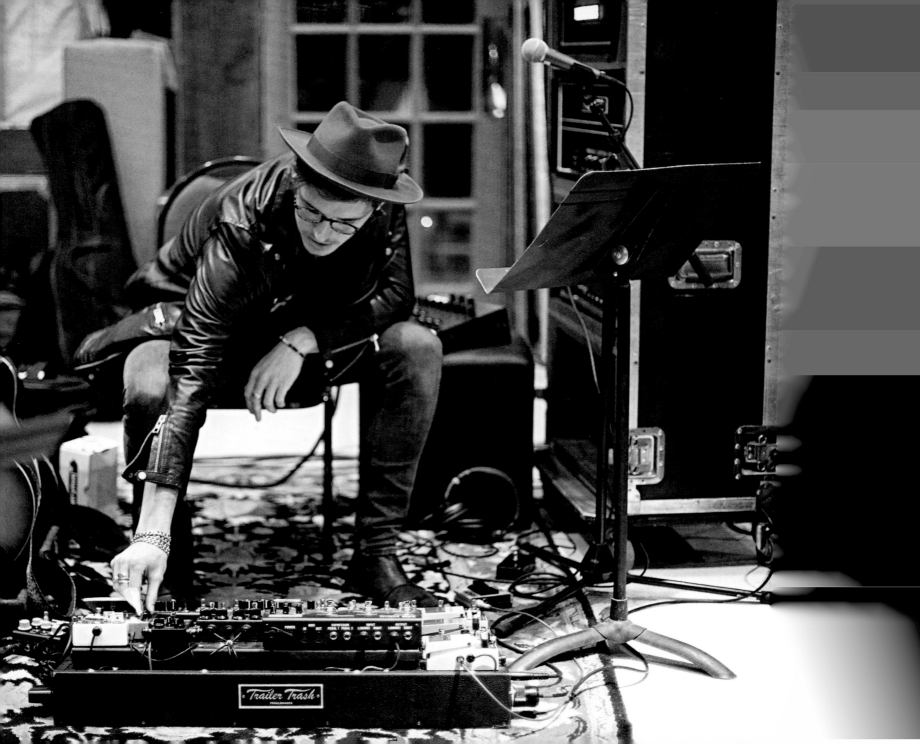

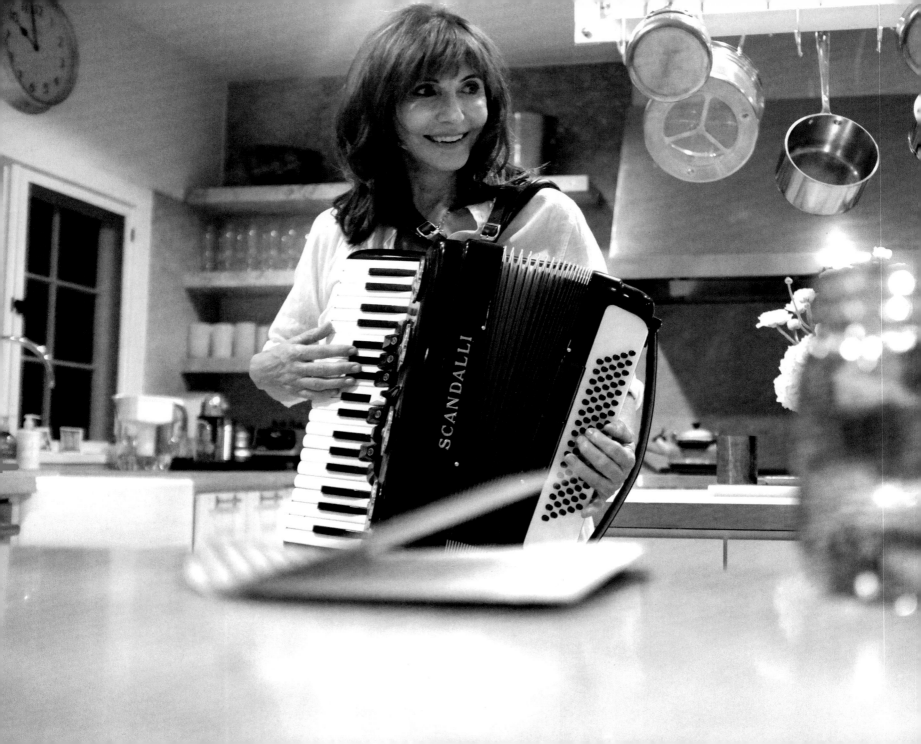

MARY STEENBURGEN AND TED DANSON

ACTRESS, SINGER, SONGWRITER (MARY)
ACTOR, PRODUCER (TED)

I FIRST CAME TO NASHVILLE in 2009. I came because Monti Olson, at Universal Music Publishing Group in Los Angeles, thought I would find kindred spirits to co-write with here. I was raised in Arkansas and have remained closely tied to my home state, so I expected to like Nashville. I wasn't prepared at all for the love affair that ensued. I fell hard. I fell hard for the people, first and foremost. Within months of my arrival, people were asking about my children by name. That might not sound like much to you, but in my world of Los Angeles, that rarely happened, especially to a celebrity. I wasn't just accepted, I was embraced, along with my family. In my adult life, Nashville has been the place where people were most interested in getting to know me, with all of my good and bad.

Then there was the writing. I came to songwriting *very* late in life. I'm known for my work in another field. I've only just started to play musical instruments. I knew I would mostly be writing with people at least half my age. I don't sing that great, and I'd rather hear anyone sing my music than me. My co-writers had every single reason to be dubious, at best. And I won't say that I didn't have to prove myself, because I did. Thank god. It would have been a disappointment if people wrote with me because I was an actor, or cut me slack for that. But I was given beautiful, generous, blessed experiences right out of the gate, and I tried with all my might to be worthy. I didn't speak of what I was doing for about five years, publicly, because I knew I had to earn the right to sit in those rooms with those astounding writers.

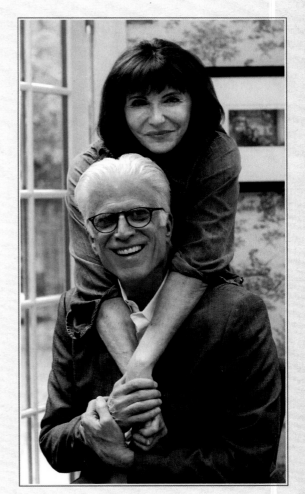

THESE PAGES: Actress Mary Steenburgen began songwriting in 2007, following a minor surgery that, upon waking, left her with a strange new appreciation for music. The accordion was a Valentine's Day gift from her husband, Ted Danson.

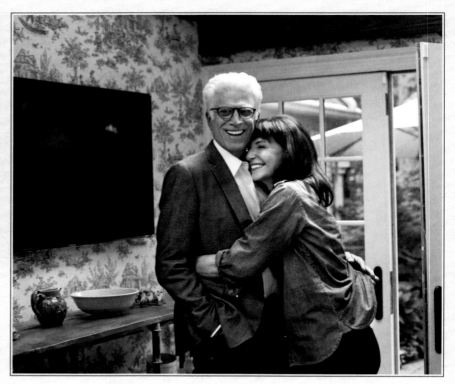

THESE PAGES: Husband and wife at home in both Nashville and Los Angeles.

We ended up buying a home in Nashville. It's filled with things that belonged to my mother and my aunt. I think my grandmother, who played the accordion, is watching while I try to teach myself how to play it. I think my mom probably appreciates that her good china is pulled out on my birthday, and that people who clearly love her daughter are eating off it. I can hear the whistles of freight trains at night, which is how my dad, a freight train conductor for Missouri Pacific, has long sung to me.

I'm honored to call myself part of Nashville, the city of poets. I love every meat and three, every humid night, the fact of lightning bugs, the hellos from strangers, the protectiveness of Nashvillians toward our privacy, *the music*, the crazily hip shops, the verdant greenness—and, maybe most of all, my terror at going out on all kinds of creative limbs here, and the nurturing place I land in when I do. It means more to me than anyone might ever guess to be a part of Nashville.—**MARY STEENBURGEN**

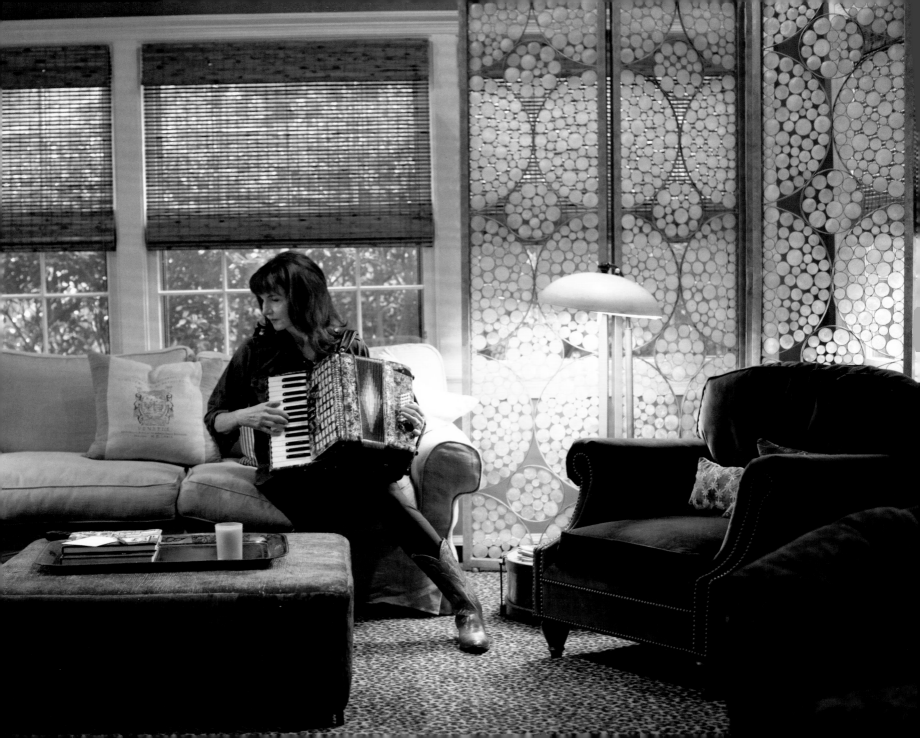

T BONE BURNETT AND CALLIE KHOURI

MUSICIAN, PRODUCER (T BONE)
PRODUCER, WRITER (CALLIE)

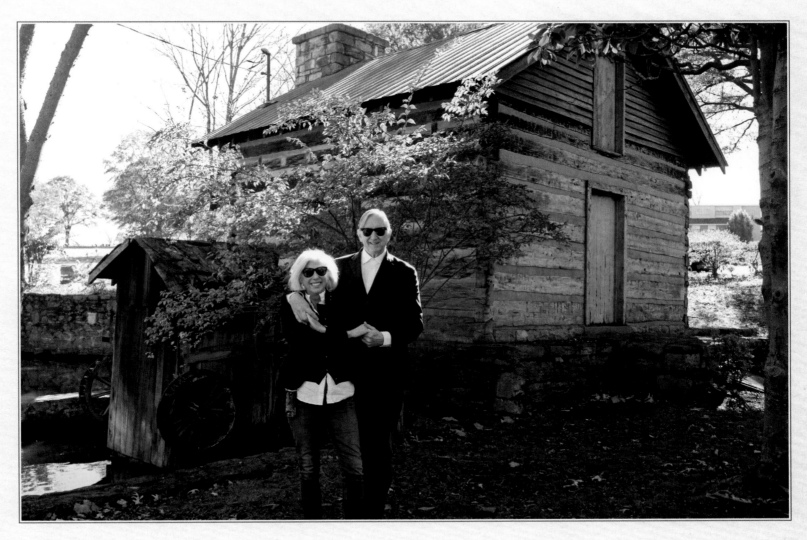

THESE PAGES: Veteran musician, songwriter, and producer
T Bone Burnett and his wife, *Nashville* creator Callie Khouri.

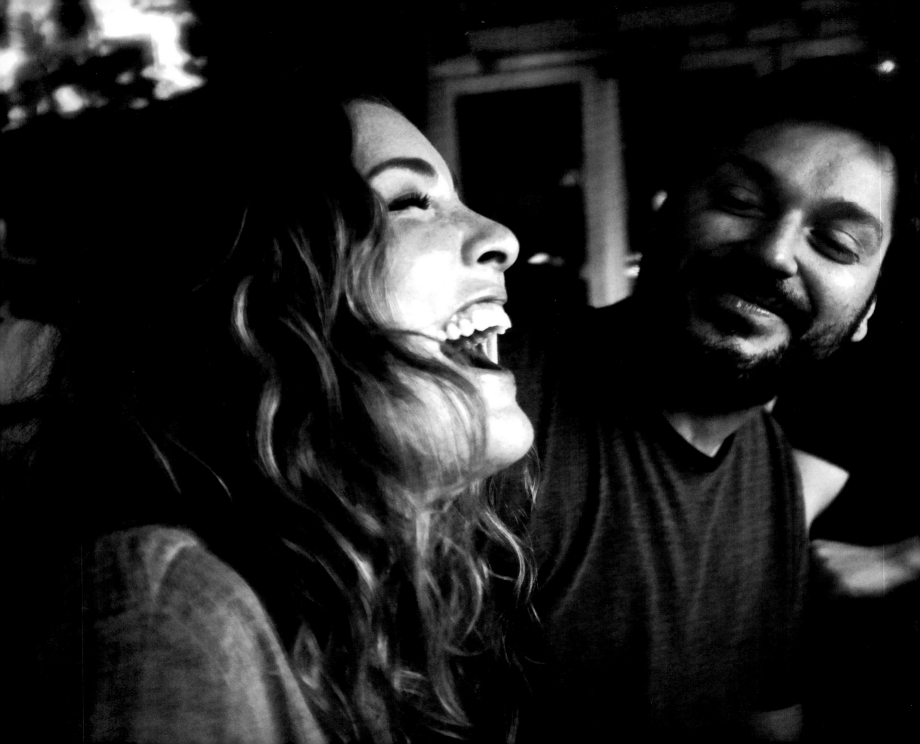

SARAH BUXTON AND TOM BUKOVAC

SINGER (SARAH)
MUSICIAN (TOM)

IWAS SEVENTEEN THE FIRST TIME I met Stevie Nicks. I could hardly believe we were in the same room together, and when she stood in front of me, I think I elevated off the ground. One of my friends told her that I was a singer, to which she replied, "Are you good?" I told her that I didn't know if I was good, but it was all that I knew I wanted to do with my life. She said, "Well then, you will make it happen. If you know you are here to be a singer, and not someone's secretary or housekeeper, then you will make it happen. And if you believe in yourself, then I believe in you." As she walked out of the room, she turned around and said, "Hey Sarah—take my place, girl." Those words, coming from my greatest musical hero, shaped my path. They led me to Nashville. They kept me hungry when I felt like quitting.

Since then, I've had a recurring dream that I was with Stevie in a room in her house, and she is either telling me stories or singing to me or showing me pieces of paper out of an old box of memories. In every one of these dreams, I am sitting cross-legged at her feet.

Last spring, my husband, Tom, got hired to play guitar on her record. Unreal. It was a two-week session, and I finally went in to hear the magic on one of the very last days. I sat next to her background singer, Sharon, on the couch and told her about when I met Stevie in 1997 and that her words have inspired my whole life and career. Sharon had to tell Stevie immediately, and then Stevie was all ears. She said, "Wait, I need to sit down to hear this." And she sat down in the engineer's seat at the console. Without thinking, I sat down at her feet, on the floor of Blackbird Studios, cross-legged, like I had in so many dreams before."—**SARAH BUXTON**

OPPOSITE: Sarah Buxton and Tom Bukovac at MAFIAoZA's in Nashville after a Skyline Motel gig. THIS PAGE: Buxton with singer Elizabeth Cook backstage.

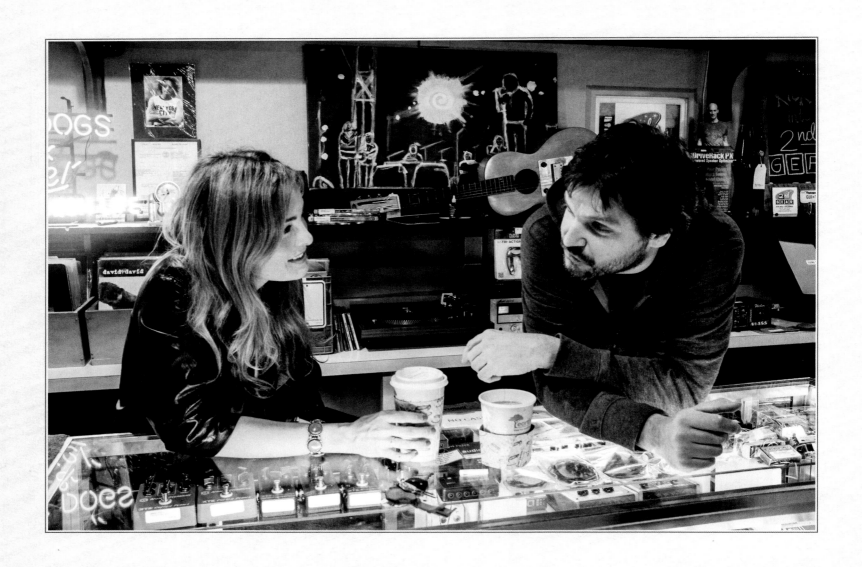

THESE PAGES: Husband and wife share coffees at Bukovac's store, 2nd Gear Used Music Consignment in Nashville. One of the top guitar players in Nashville, Bukovac is an acclaimed session musician. His small store is always packed with incredible finds.

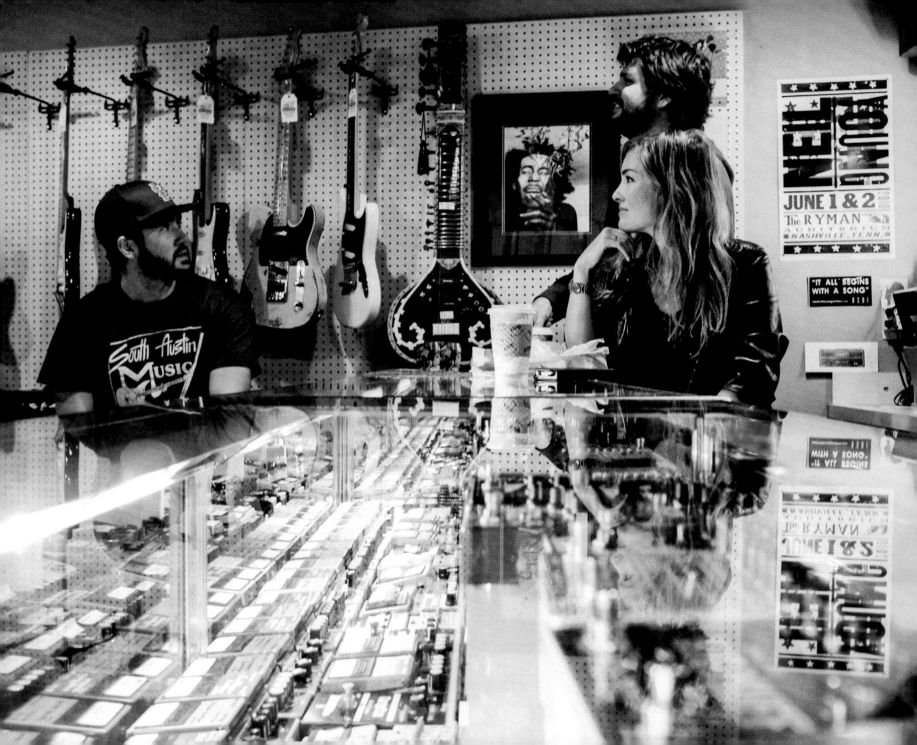

CHARLIE WORSHAM

SINGER, SONGWRITER

THESE PAGES: On the streets in East Nashville.

"Jeffrey Steele at the old 3rd and Lindsley. The Time Jumpers at the Station Inn. Those are shows you can kind of go see still, but not exactly in the same way. When I was brand new to town, those were the shows that would inspire me to stay up till daylight writing or jamming or philosophizing with one of my roommates (usually Matt Utterback) on the front porch of 1412 Villa Place, right near Music Row. I sometimes miss the pure adrenaline of my earliest days in Nashville."—CHARLIE WORSHAM

THESE PAGES: A back-up musician for Jenny Lewis, Tristen's album *CAVES* was heralded by the *Nashville Scene* Critic's Poll as "The Best Local Album of 2013."

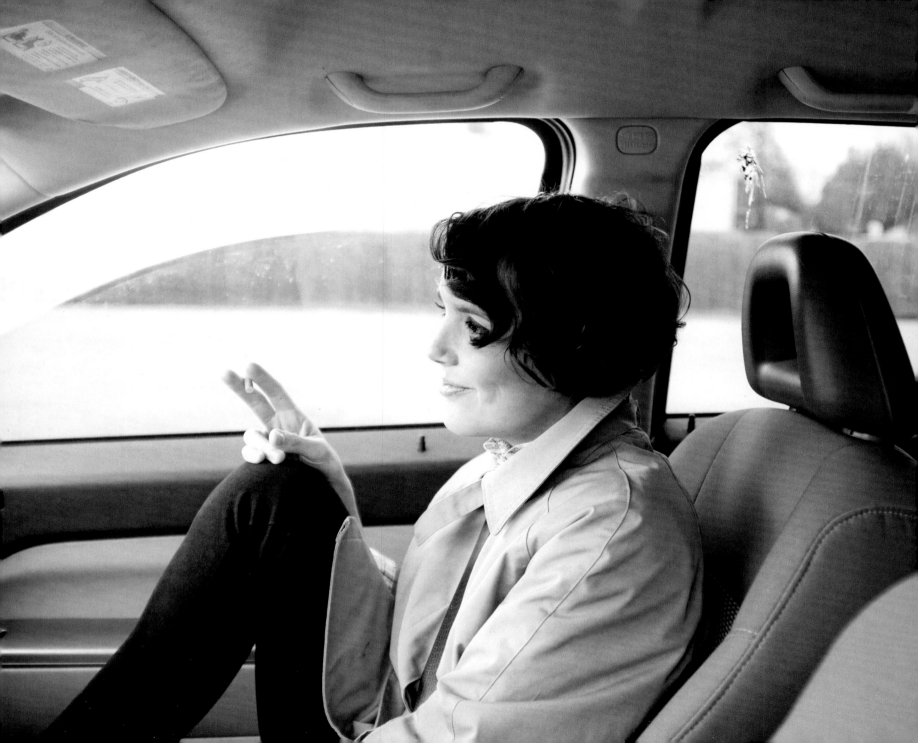

LEE ANN WOMACK

SINGER, SONGWRITER

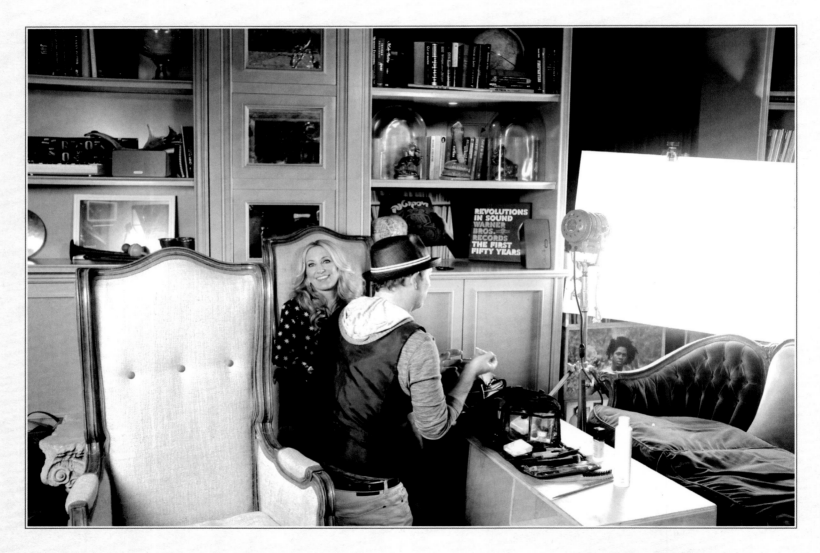

THESE PAGES: Lee Ann Womack prepares for a performance in Los Angeles during Grammy week.

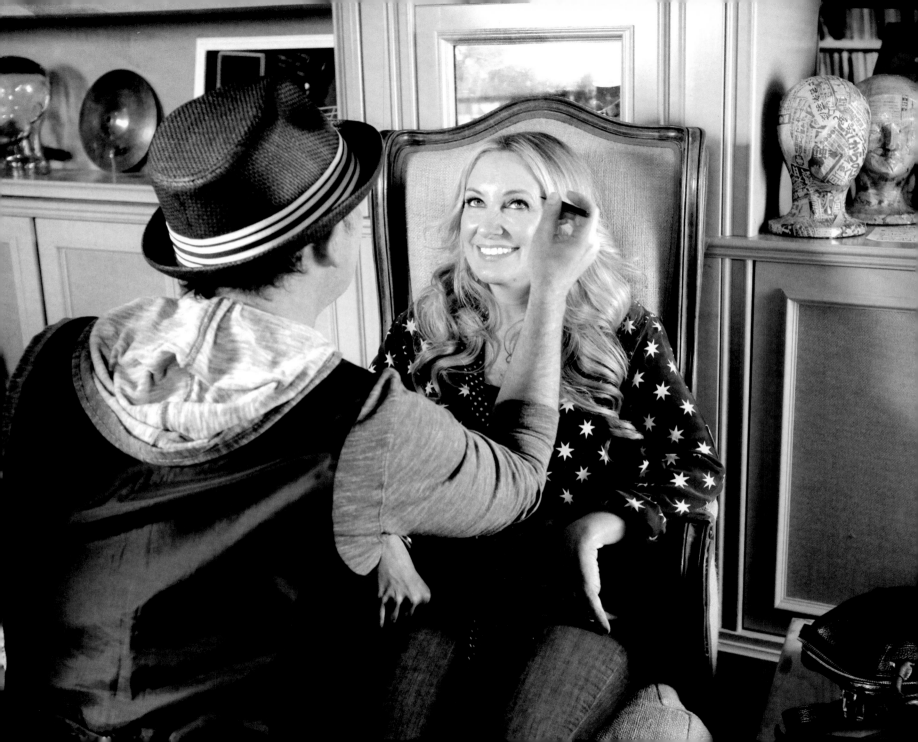

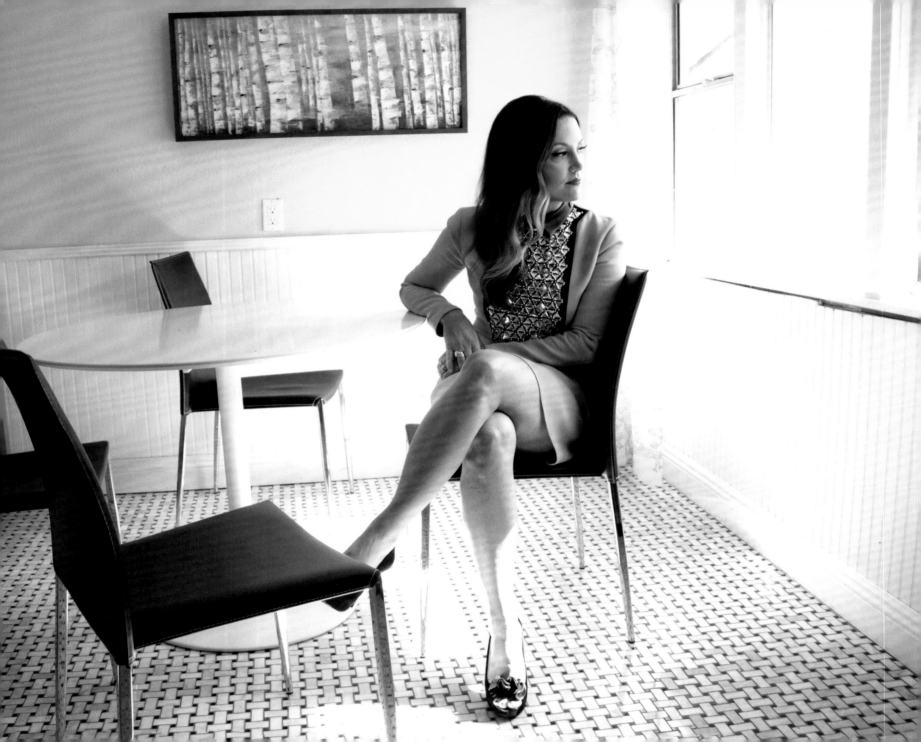

NATALIE HEMBY
SONGWRITER

GROWING UP IN NASHVILLE, I was oblivious to its beauty and its unique culture. Living here was kind of like living in a small town, and it seemed perfectly normal to cross paths with a legend or two. I thought nothing of being backstage at the Ryman, or receiving my high school diploma onstage at the Grand Ole Opry. I didn't know what a big deal it was to have Johnny Cash and June Carter come visit our church. Or how stupid lucky I was to have my first Bluebird round be with Amy Grant, Patty Griffin, Randy Scruggs, and John Hiatt. I was naive. Nashville was my hometown, and the people all felt like relatives. Some you ignored, some you paid attention to. Everybody went to church with everybody. You might run into the same person three times in one day. People lived only twenty minutes from one another.

And because it felt like a hometown, I didn't always love it. Fan Fair reminded me of waiting in line at the Atlanta Six Flags in the middle of July, hot and sweaty, smelling like BO. 12th and Porter was fun to play if you were playing 12 at 12th—but, like the old saying "Once a bridesmaid, never a bride," it was also a reminder of all the showcases I did, and all the record deals I never signed. If you were from Nashville, chances were you would eat at SATCO at least three times a week, only to be chased out of the parking lot by the Burger King lady who monitored the parking spaces for Burger King. There were no places to shop for cool clothes, except for a store in the mall called U.S. Mail. There were only a few good restaurants,

Born in Nashville, Natalie Hemby has written for Lee Ann Womack, Miranda Lambert, and Little Big Town. THESE PAGES: Getting ready for the Grammy Awards in Los Angeles. FOLLOWING PAGES: A session with fellow songwriter Daniel Tashian, with whom Hemby co-wrote "The Bees" for Lee Ann Womack.

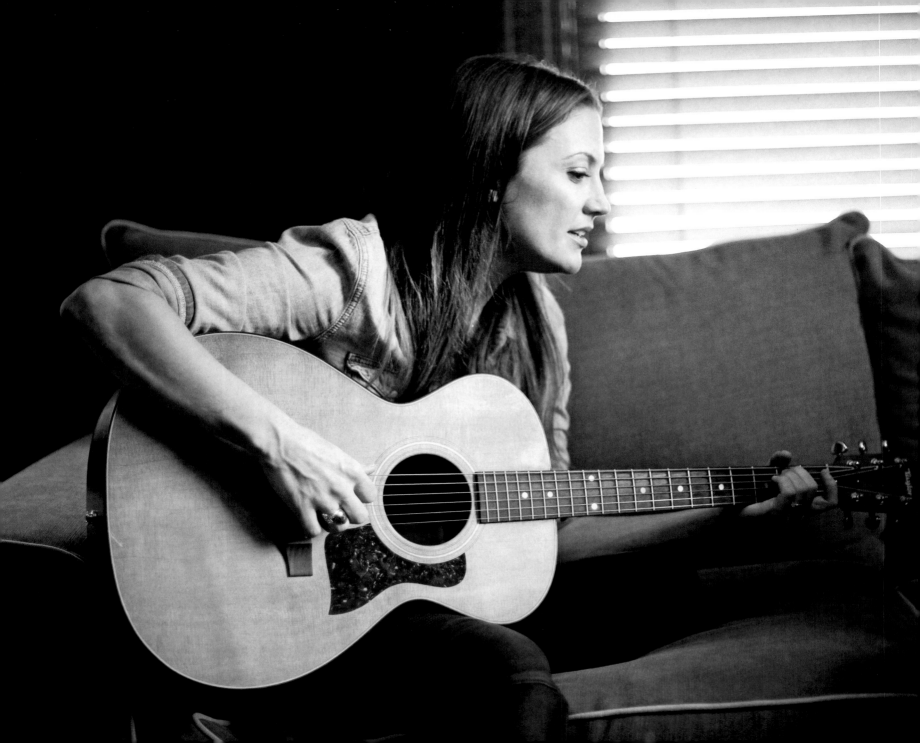

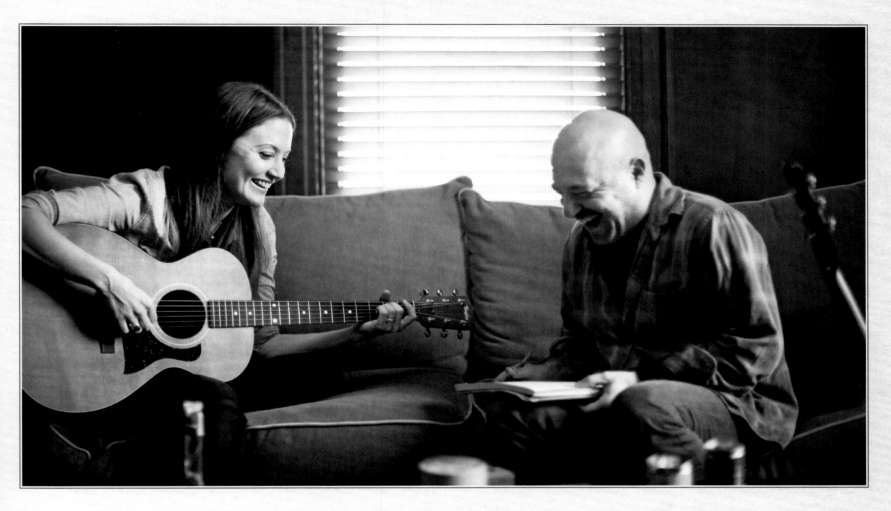

like the Sunset Grill, and a couple of "fancy" hotels—the Opryland Hotel being one of them. And the day they tore Opryland down and put up Opry Mills was one of the saddest days in Nashville. Even a flood couldn't wash away Opry Mills . . . or bring Opryland back.

As time moved on and I began to grow up a little, not only did I begin to change my attitude about Nashville—Nashville began to change. It wasn't until I lived in Los Angeles for a few months that I realized how much I loved her . . . like a teenager realizing how much she loved her parents. I came hightailing it back home and suddenly I saw how good I had it. Nashville had all my lifelong friends, my family, my old haunts and neighborhoods, the rolling hills. It was safe and it was affordable. It had the best studios and the best music. I felt like George Bailey in *It's a Wonderful Life*. Nashville was my Bedford Falls, and I promised to never leave her again.

But I never realized that she might leave me. . . .—**NATALIE HEMBY**

BARRY DEAN
SONGWRITER

"'Girls Chase Boys' snuck around the professional armor and the constant hum of the Music Row engine, and found the kid in Kansas who drove around listening to the radio, dreaming. It really did level me."—BARRY DEAN

ABOVE: Writing with Natalie Hemby and Luke Laird.
OPPOSITE: Recording the Brothers Osborne at Sound Emporium.

FIRSTS, BY THEIR VERY NATURE, are a big deal. Your first publishing deal, cut, and hearing your song on the radio . . . they all lock into those pictures you carry forever inside. With "Girls Chase Boys," which I collaborated on with Ingrid Michaelson, I had an amazing experience. Maybe it's because I'm working inside the Nashville community so much, but songs on country radio are very connected to business. I'm watching how they're doing on the chart and comparing and studying what I can do better or differently. But with that song being on the pop chart—I heard it on the radio and I felt fifteen years old. "Girls Chase Boys" snuck around the professional armor and the constant hum of the Music Row engine, and found the kid in Kansas who drove around listening to the radio, dreaming. It really did level me.

There are lots of memorable Nashville moments like that one—part of it is, I think, writers train themselves to remember, to notice. But if I had to mention one off the top of my head . . . Little Big Town recorded "Pontoon," and it had just become the single when they played the Ryman, early in their tour. They did the song midway through the show, and it was very exciting. They are amazing. The song hadn't really broken through yet, so very few people knew it. The next time I saw them, they were in a great big place. The song had moved second to last, and the whole crowd was just losing its mind and singing along. Don't get me wrong—I love to hear a song I had something to do with on the radio. It's very moving. Still, I think there's something that drives me as a writer, and others I've talked to have said they agree: We want to write the songs people sing along to, and sing to themselves when they're alone—the ones they hold on to.

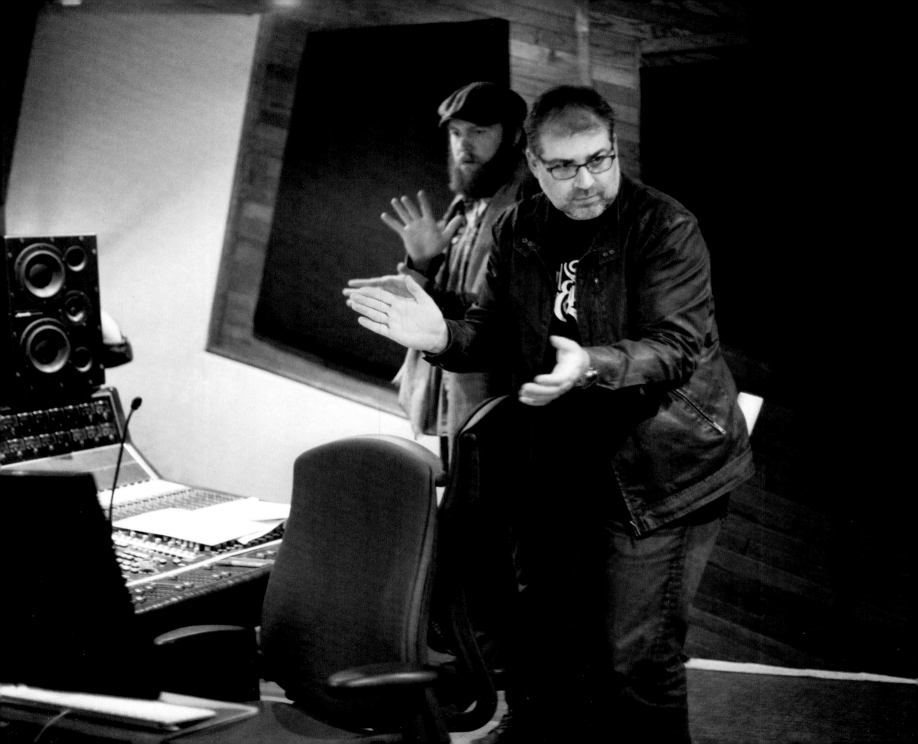

BUSBEE

SONGWRITER, PRODUCER, PUBLISHER, MUSICIAN

"She sets her table under an open sky and sings as the sun falls behind the city skyline. She gives a seat to all who enter, and she loves music—oh, does she love music."—BUSBEE

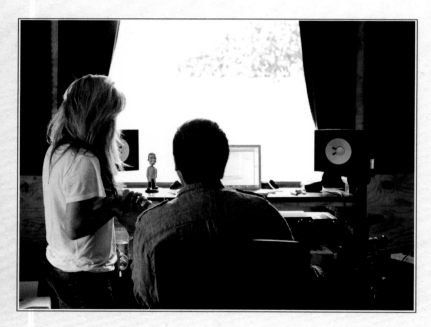

THESE PAGES: With Lucie Silvas at busbee's home studio in Los Angeles.

THERE ARE A LOT OF THINGS I love about Nashville. She holds her doors open with a small-town charm, even while becoming a major metropolis. At her doorstep are rolling hills, blanketed with trees and punctuated by creeks and lakes. She sets her table under an open sky and sings as the sun falls behind the city skyline. She gives a seat to all who enter, and she loves music—oh, does she love music.

My first visits to Nashville in early 2006 were to write with my friend Greg Becker. He opened the doors to his musical family, and through him I met Darrell Franklin. My second meeting with Darrell took place in an office on the row that he was either moving out of or moving into, I can't remember. But either way, there was no furniture, and we had to listen to my songs using a boombox while sitting on the floor. It was there that he offered me a publishing deal. There was no pretense—only passion for the music.

Since that time, I have had the distinct privilege of getting to know more of the family. Each time, the door is open and the music is playing. Nashville is a city that needs no pretense. She doesn't need the gilding, because her heart is gold.

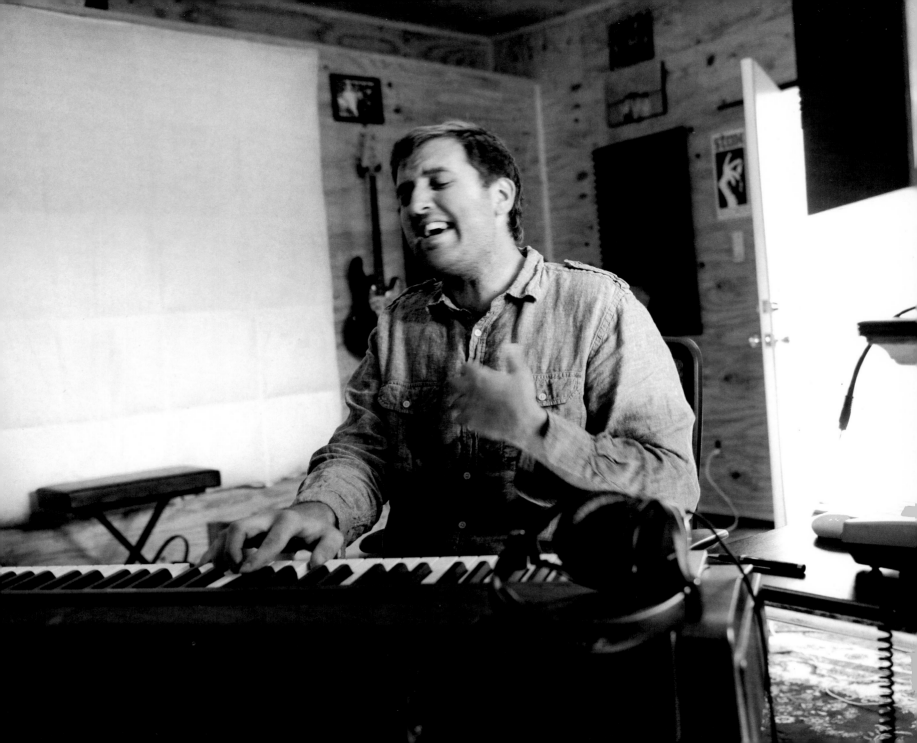

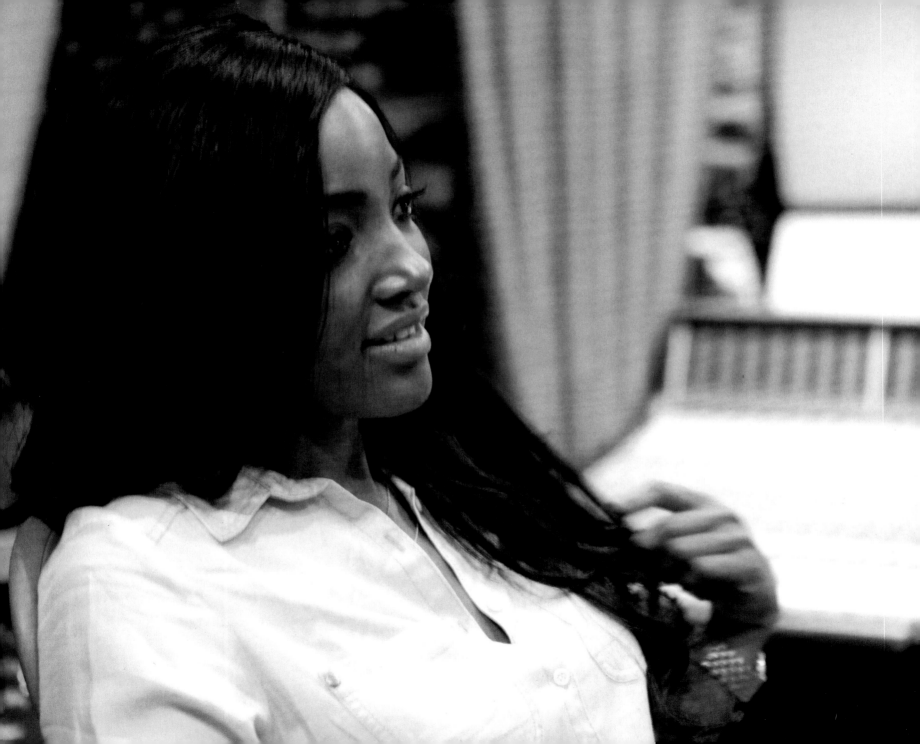

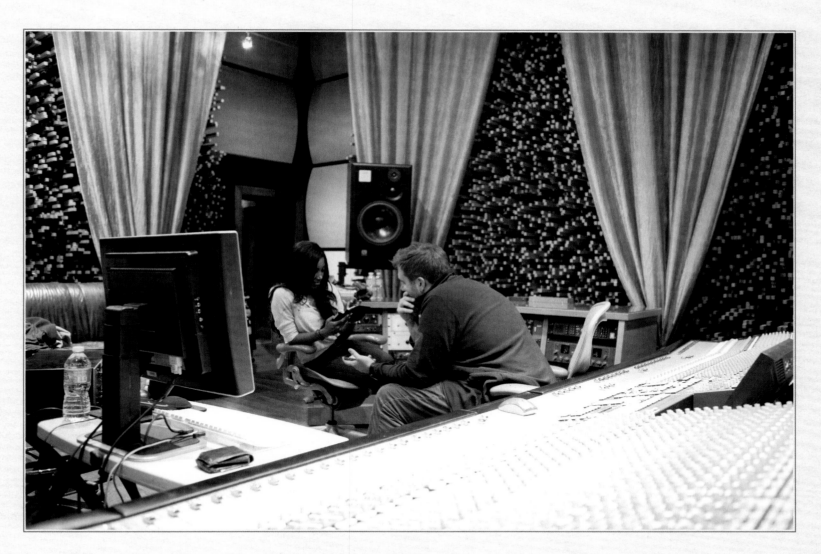

DEAN AND JESSIE JO DILLON

SONGWRITERS

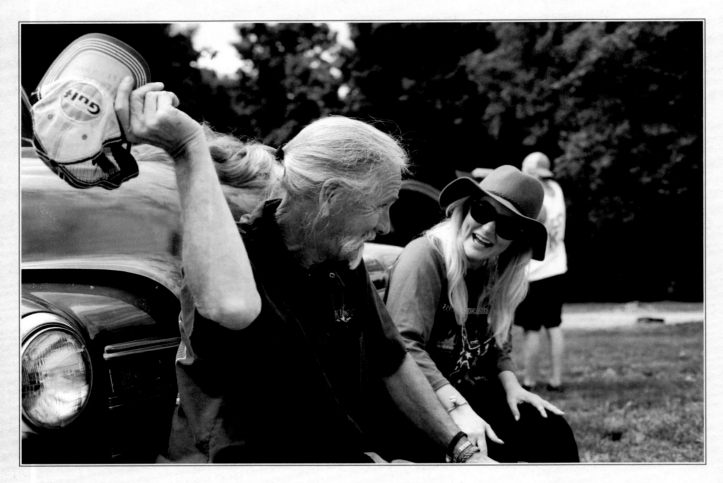

THESE AND FOLLOWING PAGES: Dean Dillon and his daughter, Jessie Jo, on the legendary country songwriter's farm after a garage sale. Since the '90s, Dean has penned many singles for other artists, most notably George Strait. Dean and his daughter remain frequent collaborators.

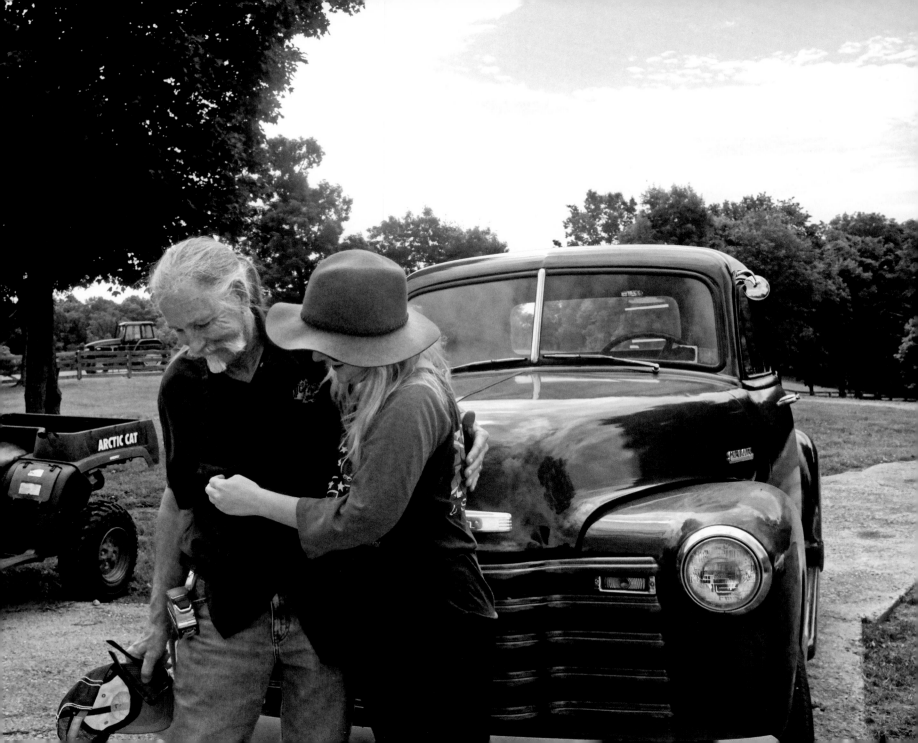

APPROACH WITH CAUTION

Phillips
66

AVIATION PRODUCTS
U.S. GOVERNMENT LICENSED
AIRPLANE
PILOT
ON DUTY
24 HOURS A DAY

STOP

CITY OF CHICAGO

Free
WASH
with LUBE
and OIL CH

POWER TO

Sinclair
DINO

GASOLINE

TOTAL $ 0.0.0 SALE

0 0 0
GALLONS
CENTS PER
GALLON 4 3 1

ETHYL

JAY JOYCE
RECORD PRODUCER, SONGWRITER, SESSION MUSICIAN

THESE PAGES: Jay Joyce sits on the steps of Neon Cross Studios with his dogs. Joyce built the studio in an old church in East Nashville.

YEARS AGO, I got a call from a production company asking if I could be the "Rock Guitar Player" in a Johnny Cash video. This was before the Rick Rubin era, so Johnny was not getting a lot of attention then.

Of course I said yes. I just assumed that I'd be playing in his band. When I got there, I found out it was just going to be me and Johnny, and that Johnny wanted to meet me before we filmed.

So I sat there waiting nervously. I could hear footsteps coming down the hall and sure enough in walks The Man in Black along with his wife, June. He seemed ten feet tall and his aura just filled the room.

Johnny turned out to be one of the funniest and most gracious people I've ever come across. We laughed and posed and rocked all day. At the end of the day, in typical Johnny Cash voice, he said, "Everyone's gonna be wondering who that old man is in Jay's video."

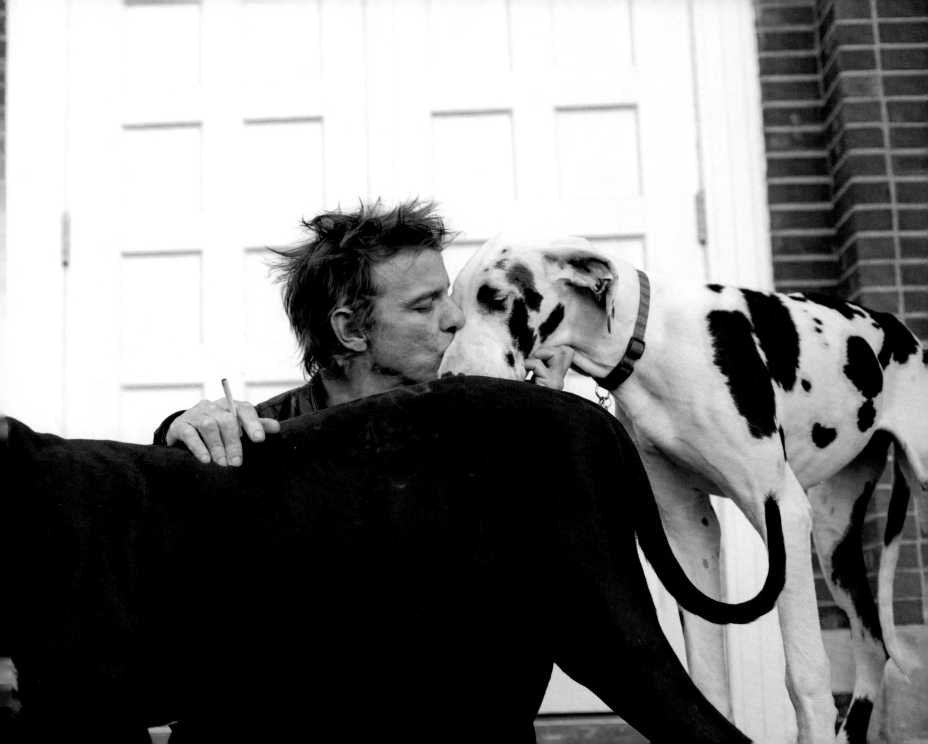

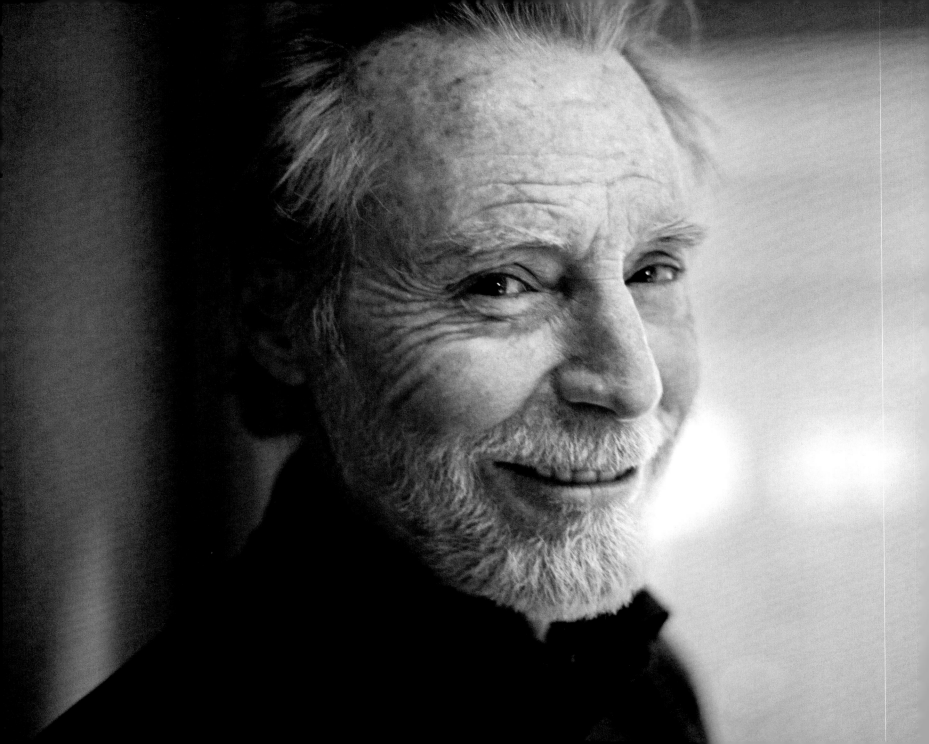

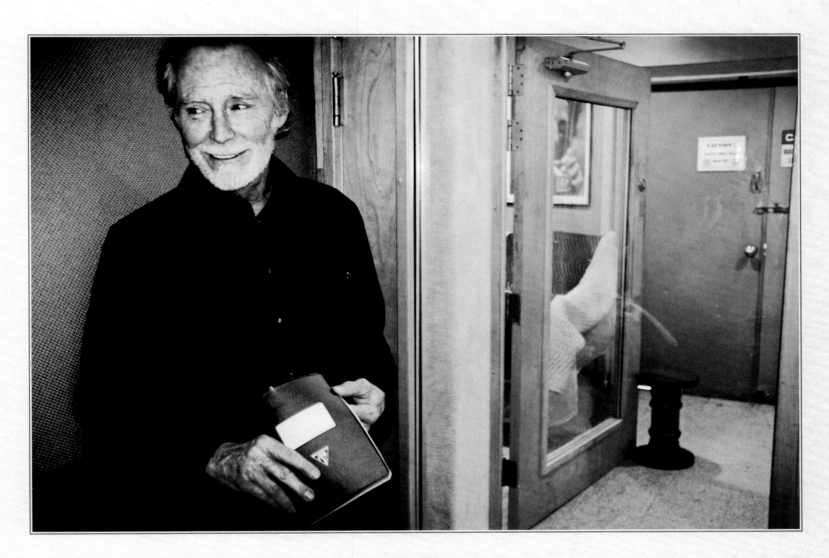

THESE PAGES: J.D. Souther during a demo session at Easy Eye Sound Studios in Nashville. Souther has written and co-written hits with Linda Ronstadt, James Taylor, and the Eagles, and also portrays producer Watty White on *Nashville*.

BRANDY CLARK
SINGER, SONGWRITER

THESE PAGES: Brandy Clark before a Grammy-week performance.

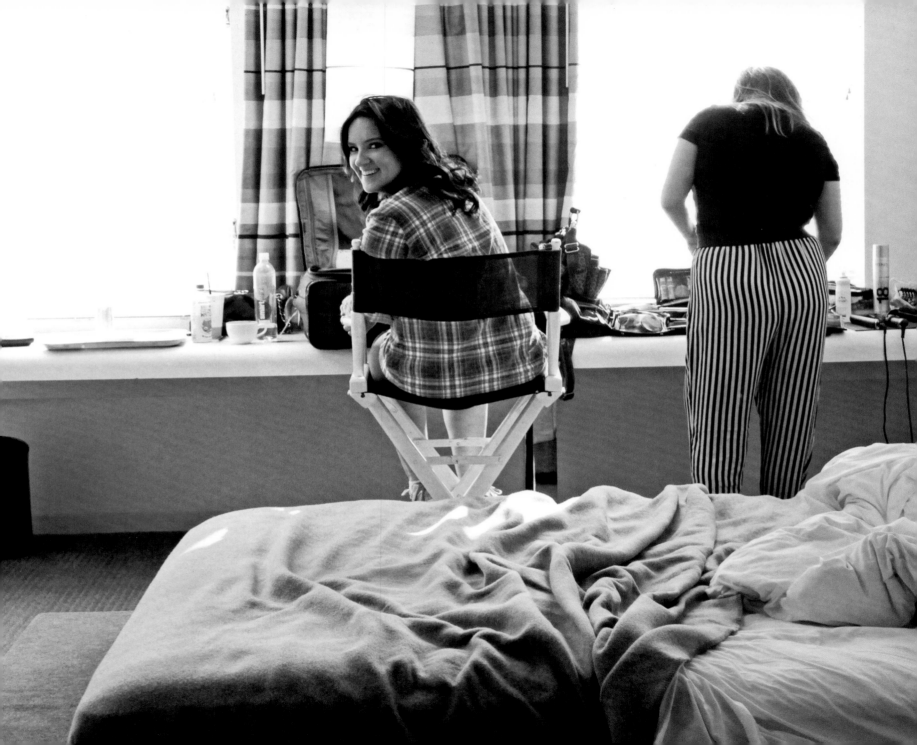

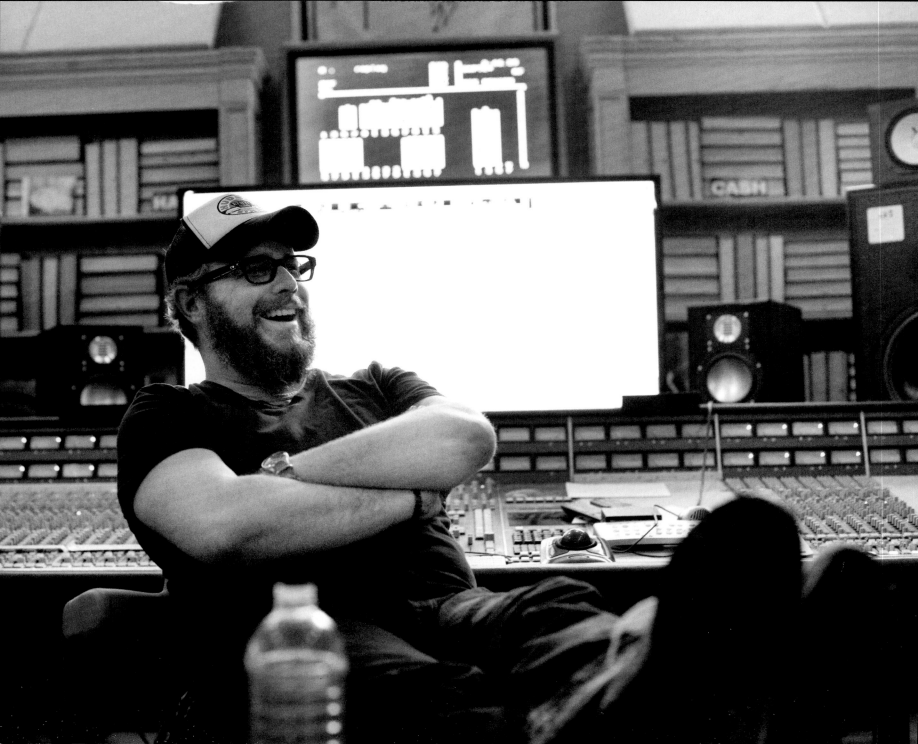

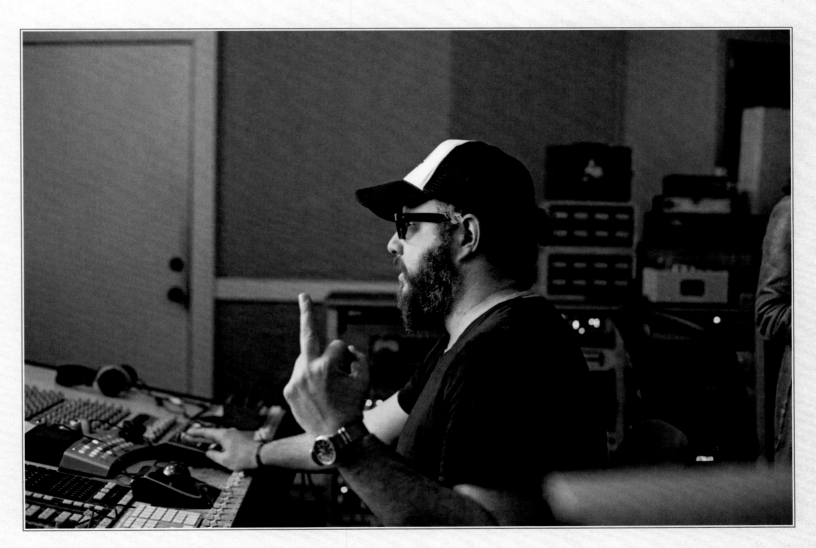

THESE PAGES: Multiple Grammy Award—winning
producer F. Reid Shippen at his studio Robot Lemon.

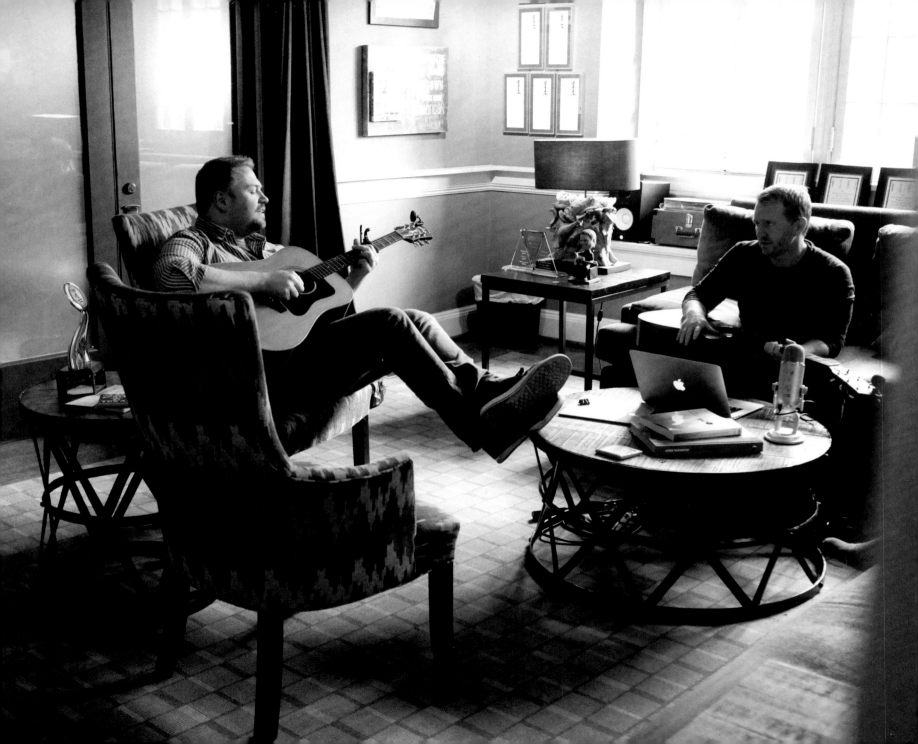

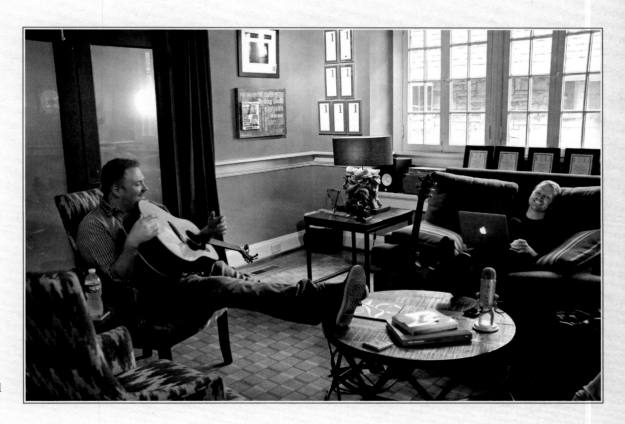

THESE PAGES: Established country music producers Shane McAnally and Josh Osborne at their Music Row offices. The pair have several #1 hit singles to their credit and have written for Luke Bryan, Tim McGraw, Blake Shelton, Kelly Clarkson, and more.

A FEW YEARS AGO, Kenny Chesney was going in the studio to record a song that Josh Osborne, Sam Hunt, and I had written called "Come Over," when I got a text from Kenny's producer, Buddy Cannon, saying that they wanted to replicate the sound of the background vocals on our demo. He assumed I was the one singing them, so he asked if I would come in and sing on Kenny's record.

I stared at that text for a long time, before painfully finally texting back that it wasn't me singing. It was actually Josh. Still, Buddy knew what it would mean for either of us to get to sing on Kenny's cut, so he graciously responded, "Well, I'm gonna need Josh's number . . . and, you should get down here, too . . . we'll find a part for you." —SHANE McANALLY

ASHLEY MONROE
SINGER, SONGWRITER

"Nashville is such a tight-knit community. It feels like family." —ASHLEY MONROE

THESE PAGES: Ashley Monroe packs a few must-have items for tour. Her album *The Blade* has received universal acclaim, with *The New York Times* calling her a "sly, progressive songwriter."

OPPOSITE: Kree Harrison in the Hollywood Hills. ABOVE: Outside the Hollywood Bowl after the "We Can Survive" benefit show. An all-female bill of performers, including Katy Perry and Ellie Goulding, gathered to raise money in support of young women battling breast cancer.

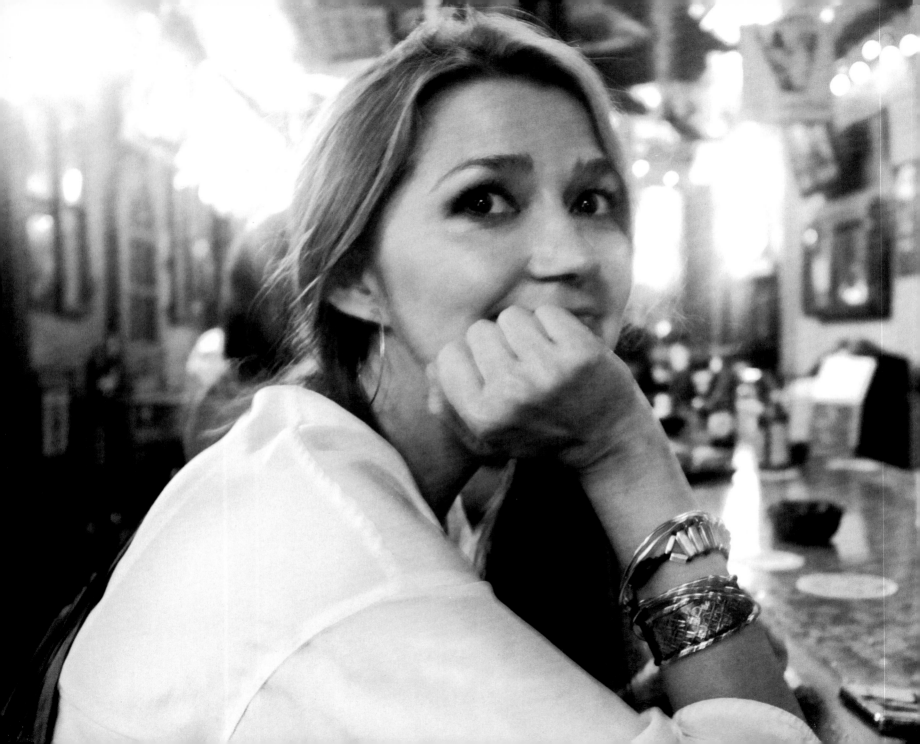

MATRACA BERG

SINGER, SONGWRITER

YOU KNOW THAT SONG with the line, "too many memories for one heart to hold"? That would be my life in the business, starting at four years old. I was raised in a musical family around future Hall of Fame songwriters, who were broke, of course. Red Lane would come over to our little apartment and sit at the kitchen table with me and proceed to come up with beautiful melodies to nursery rhymes. He played them till I could sing along with him. Then he would move to the harmony part. My aunt Sudie was a popular backup singer, my whole family sang! But he engaged me in such a way that it wasn't just my family business, he made me feel special. He made me feel I was part of it and I always would be. The night my mentor, Bobby Braddock, inducted me into the Songwriters Hall of Fame was the most profound for me. My mother died young, so it was emotional on so many levels. I somehow gave a speech, through many tears, looking out at so many people who lifted me up through the years, especially Pat Higdon. Then I saw Red Lane in the very back in his sports jersey (dressed for the occasion as usual), and when I finished, he walked out. He just came for that. I think he was missing mom too. I adored and worshipped that man . . . to the very end. When he was dying, he gave me an incredible song idea. I'm waiting for the right time and the right angels around me to write it.

THESE PAGES: The three-time Grammy Award–winning singer-songwriter relaxes at a bar in Nashville.

CAITLIN ROSE
SINGER

THESE PAGES: Caitlin Rose at home in West Nashville. The daughter of songwriter Liz Rose, Caitlin has been likened to Patsy Cline for her rich, expressive voice.

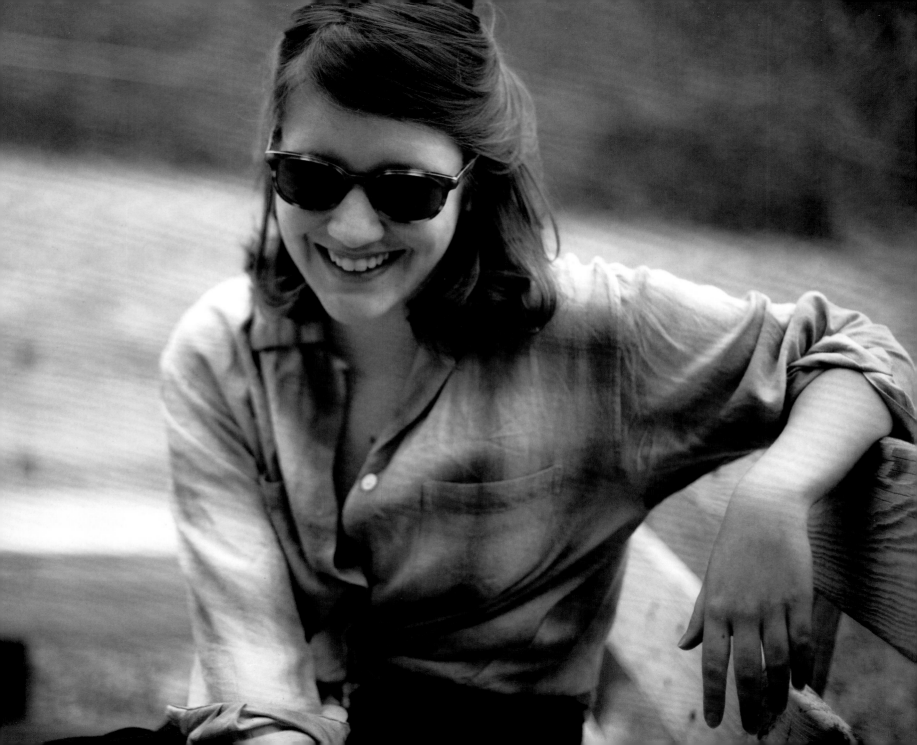

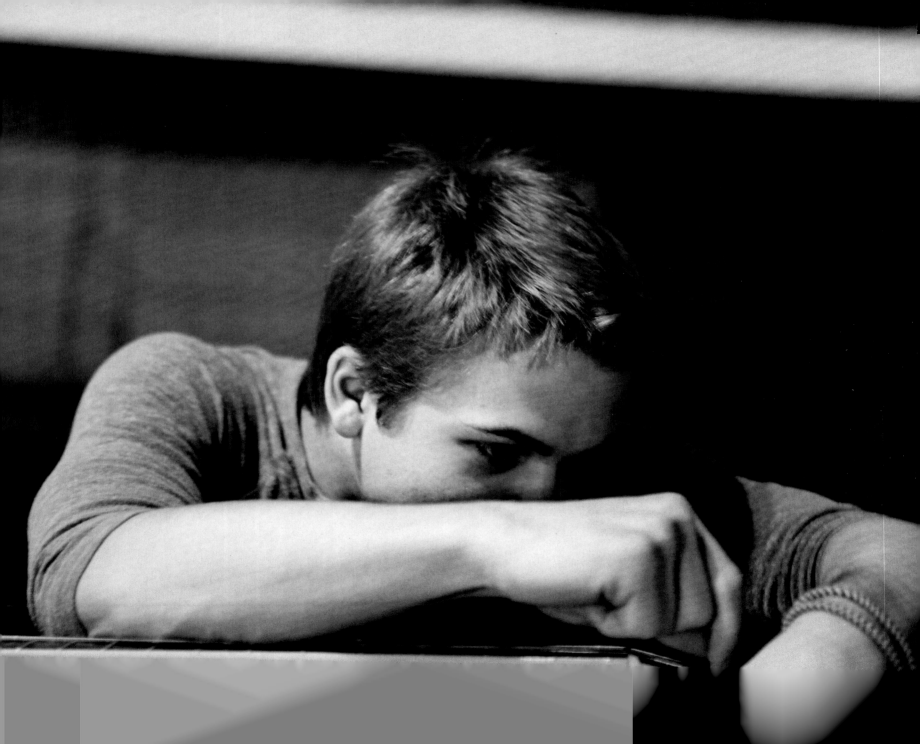

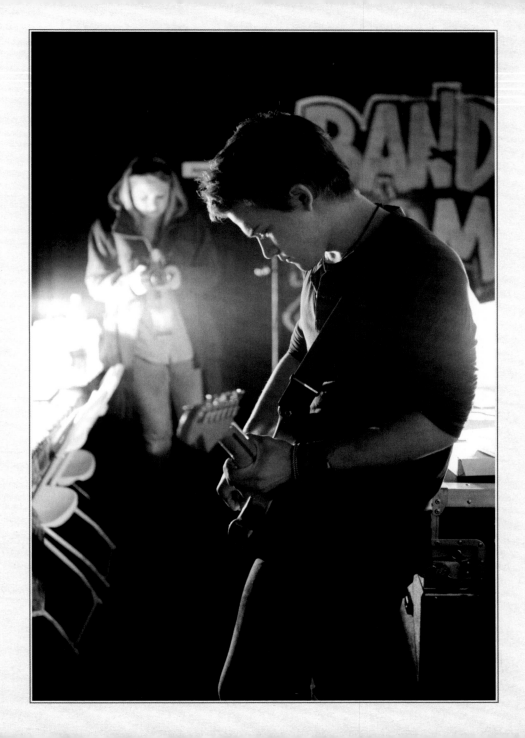

HUNTER HAYES
SINGER, SONGWRITER, MULTI-INSTRUMENTALIST

THESE PAGES: Backstage at the South Side
Saloon in San Bernardino, California.

JAMES KICINSKI-McCOY

WRITER, BLOGGER AT BLEUBIRD AND *MOTHER MAGAZINE*

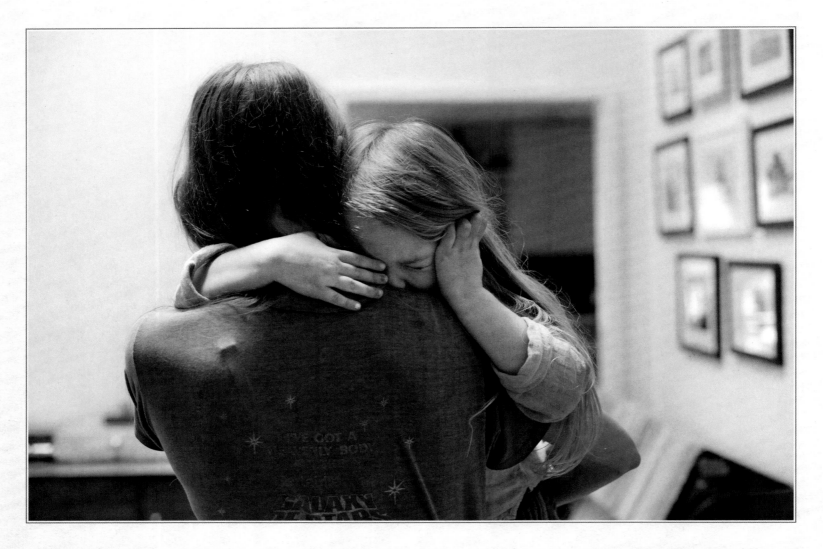

THESE PAGES: The Nashville-based lifestyle blogger and writer at home with her children.

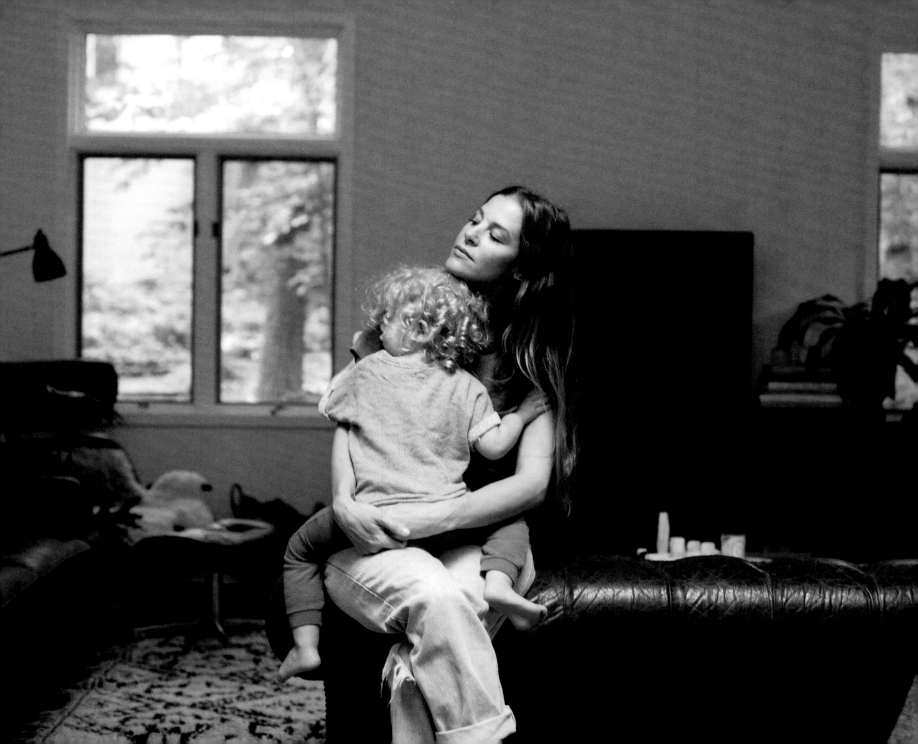

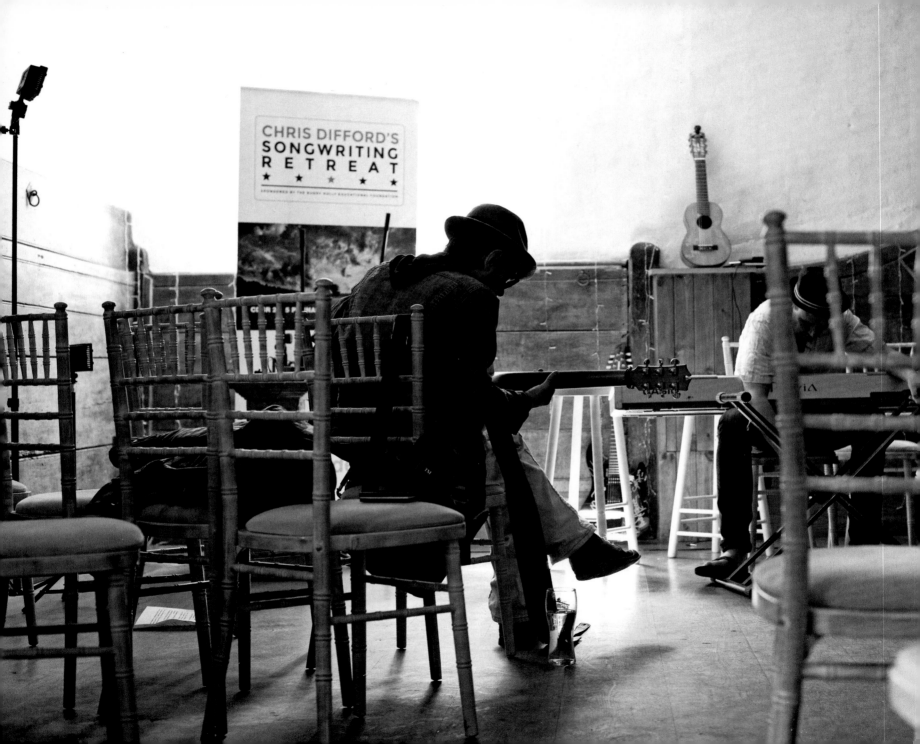

CHRIS DIFFORD'S SONGWRITING RETREAT

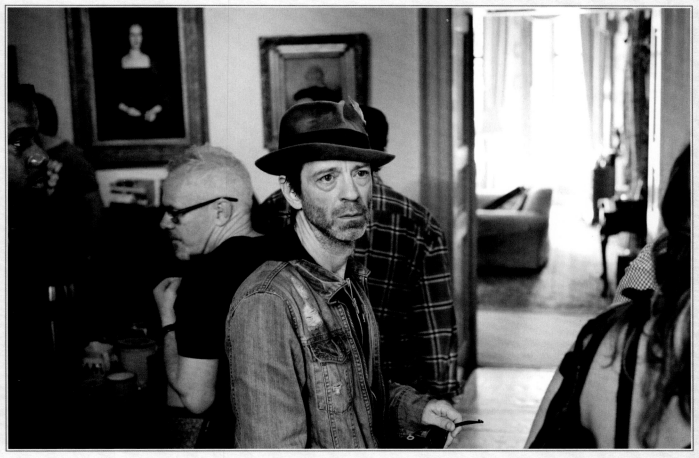

THESE PAGES: Singer-songwriter Travis Meadows at a songwriting retreat in Glastonbury, England.
FOLLOWING PAGES: Nashville-based songwriter Jeremy Spillman tips a bagpiper on the streets of Glastonbury.

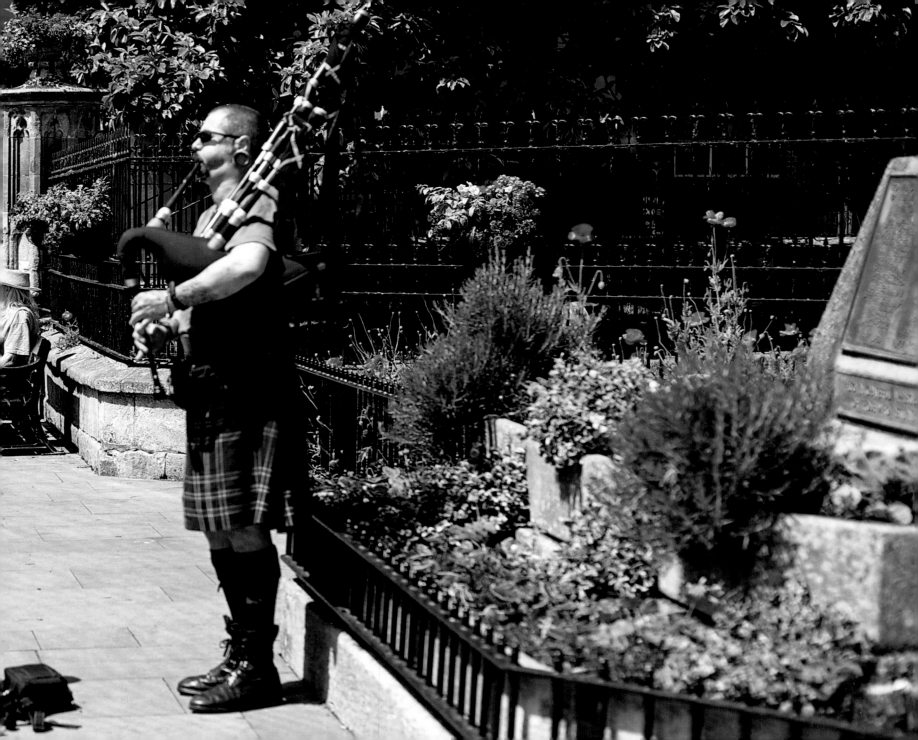

CHRIS GELBUDA

SINGER, SONGWRITER, PRODUCER

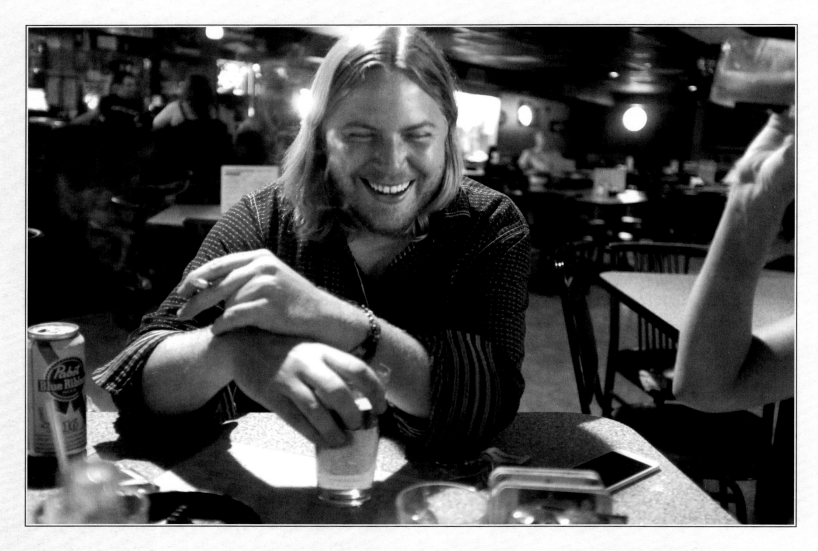

ABOVE: The songwriter, who has written and produced songs for Meghan Trainor, at Edgefield Sports Bar and Grill in Nashville. OPPOSITE: Ian Fitchuk at Melrose Billiards. Fitchuk has worked on many records, including Grammy-nominated albums by James Bay and Kacey Musgraves.

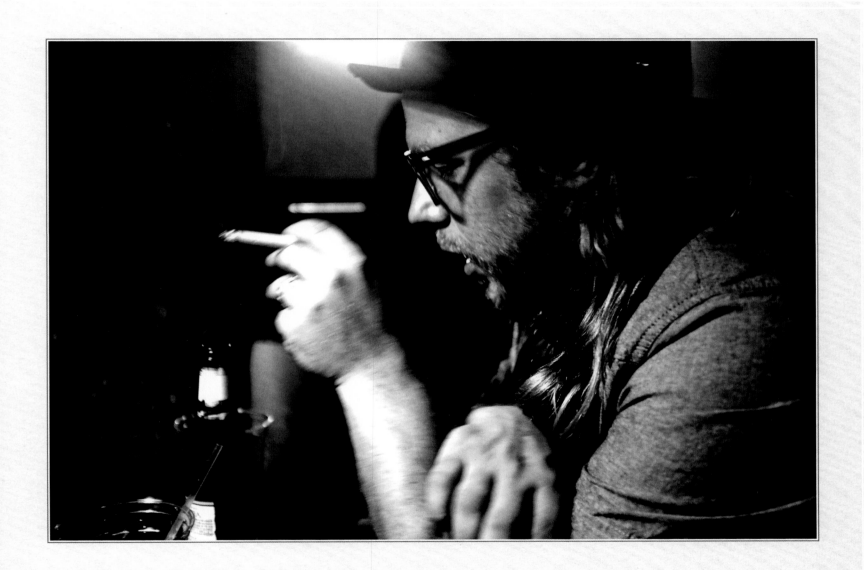

KEN LEVITAN
FOUNDER OF VECTOR MANAGEMENT

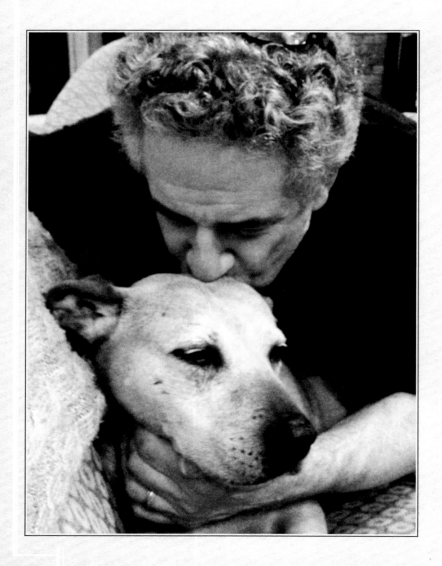

I **ARRIVED IN NASHVILLE** in August 1975. I was starting school at Vanderbilt and had driven from New York with a couple of friends, loaded down with luggage in an old Chevy Kingswood Estate, not knowing really what to expect. I immediately began exploring the musical landscape.

The first few days in town, I saw so much music. It began my love affair with Nashville. In the first week or so, I saw Willie Nelson, Asleep at the Wheel, Guy Clark, Jerry Jeff Walker, Tracy Nelson, Charlie Daniels, John Hiatt, Sonny Terry and Brownie McGhee, and Larry Raspberry and the Highsteppers. I was hooked. I still am. No other city rivals the musical diversity and access to talent that Nashville has. I am so glad I discovered it.

Here's a Nashville memory: There used to be a bar in town called Waxies. In college, we would gather there to play pinball and drink fifty-cent beers. One night in the late '70s, Steve Buchanan and I were in there, drinking beer and playing pinball, when Bobby Bare Sr. walked in with his wife. Bobby got a roll of quarters, and we began playing pinball with them. As the night grew later and later and all of us got a little more drunk, the conversation turned to new music Bobby was making, and he invited us over to his office to listen to his new recordings. He had just recorded the Johnny Otis song "Willie and the Hand Jive." We spent the rest of the night drinking beer, dancing around in his office, and listening to that song maybe a hundred times. An early education in the music business.

THESE PAGES: Nashville music executive Ken Levitan represents top talent in Music City, including Emmylou Harris and Kings of Leon.

OPPOSITE: Friends Ken Levitan, Jack Spencer, and Mickey Raphael gather at Adele's Restaurant, surrounded by Spencer's work. Raphael is a professional harmonica player who has performed with Willie Nelson, Vince Gill, and Emmylou Harris. ABOVE: Jack Spencer takes a smoke break outside Adele's.

149

KRIS KRISTOFFERSON
SINGER, SONGWRITER, MUSICIAN, ACTOR

OPPOSITE: Kris Kristofferson records
a song on the Cayamo Cruise.

LIZ ROSE, LORI McKENNA, AND HILLARY LINDSEY

SINGERS, SONGWRITERS

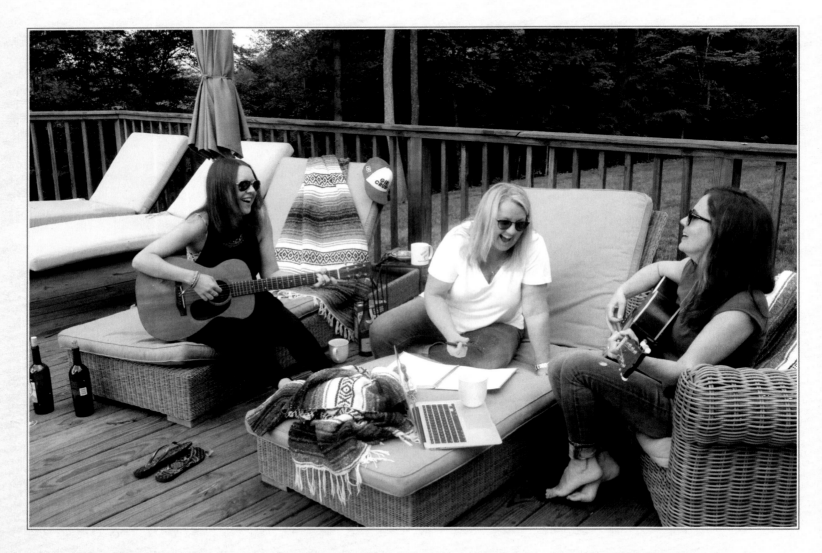

ABOVE: From left: Hillary Lindsey, Liz Rose, and Lori McKenna at Rose's house in Nashville. OPPOSITE: The trio of songwriters has written for the likes of Little Big Town ("Girl Crush") and Eli Young Band and has dubbed themselves "The Love Junkies" after their affinity for a certain subject matter.

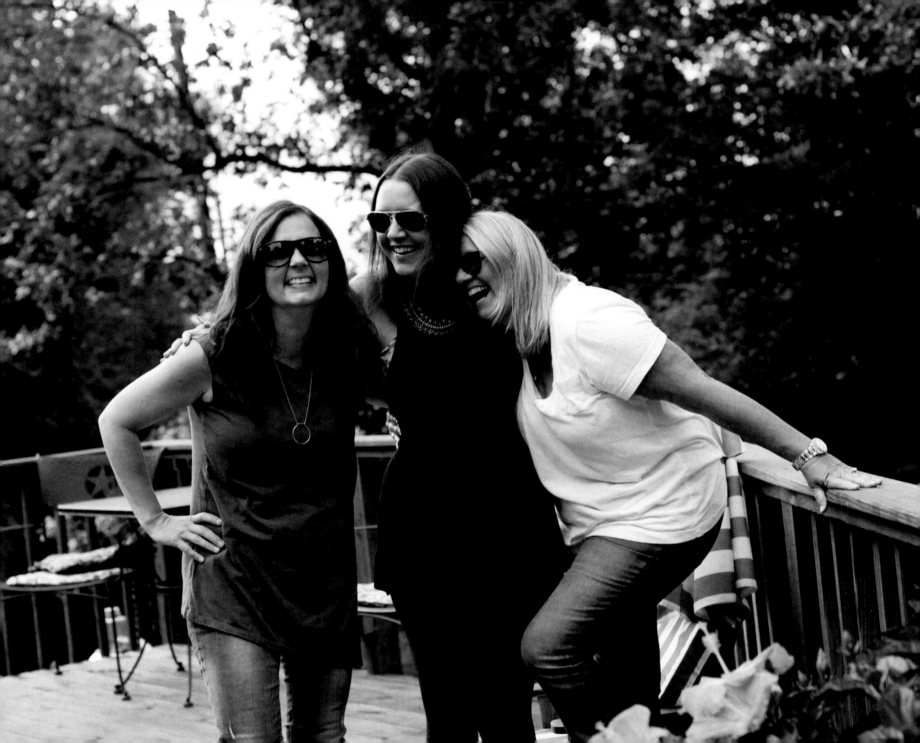

LUCINDA WILLIAMS
SINGER, SONGWRITER

ABOVE: Lucinda Williams, Brandi Carlile, and Buddy Miller on the Cayamo Cruise.
OPPOSITE: Lucinda Williams was named "America's best songwriter" by *TIME* magazine in 2002.

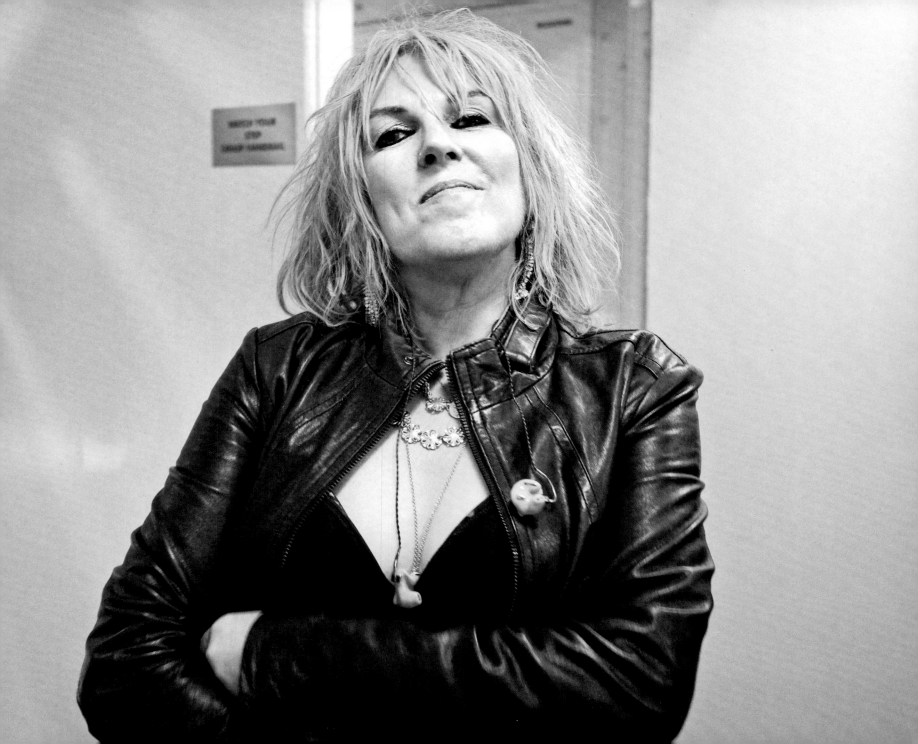

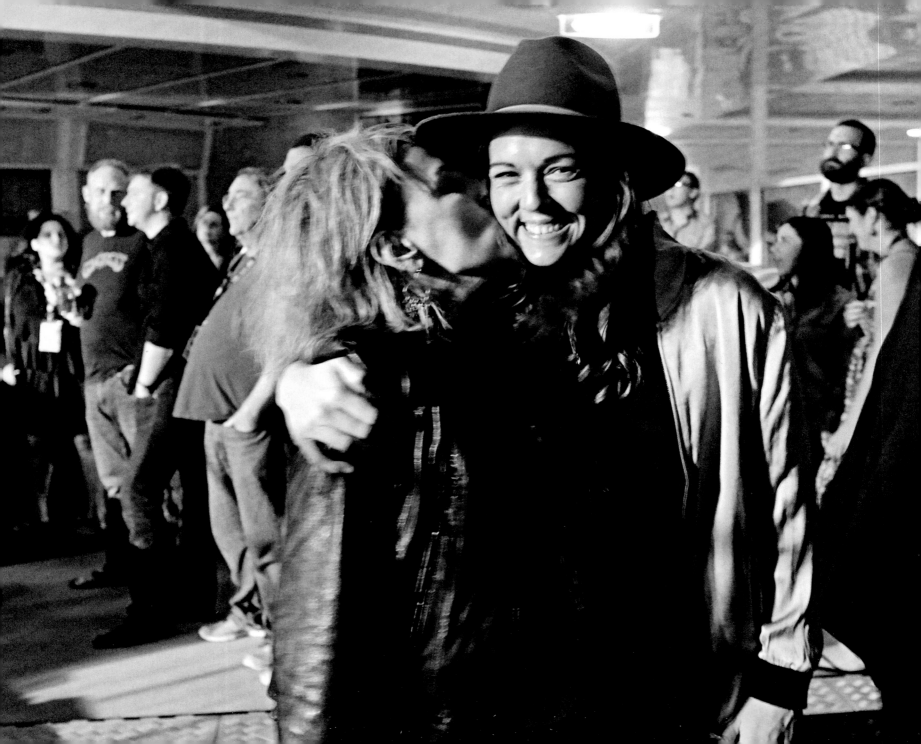

THESE PAGES: On the Cayamo Cruise.

BUDDY AND JULIE MILLER

SINGER, SONGWRITER, PRODUCER (BUDDY)
SINGER, SONGWRITER (JULIE)

ABOVE: Julie Miller has had her songs recorded by such artists as Miranda Lambert, Lee Ann Womack, and the Dixie Chicks.
OPPOSITE: Buddie Miller, at home in his studio, has produced albums for such artists as Robert Plant, Patty Griffin, and Ralph Stanley.

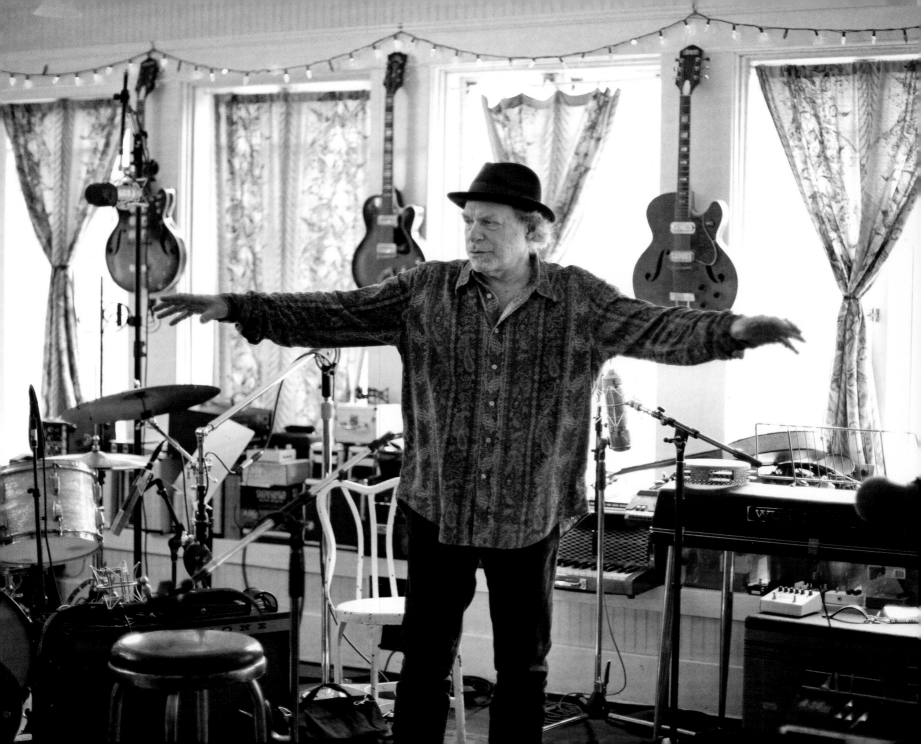

PATRICK CARNEY

MUSICIAN

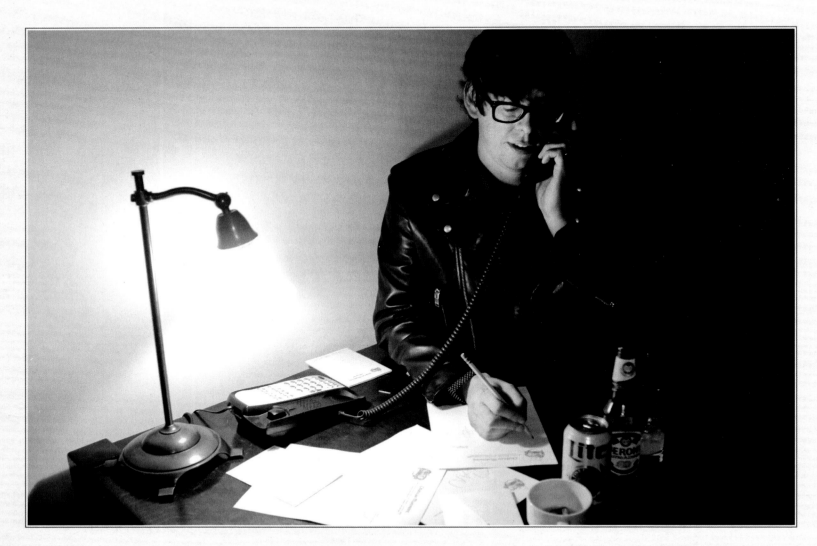

ABOVE: Patrick Carney of The Black Keys at the Chateau
Marmont in Los Angeles after the Grammy Awards ceremony.

ABOVE: The lead vocalist for the band Sixpence
None the Richer at The 5 Spot in East Nashville.

AFTERWORD

I **CAME TO NASHVILLE** when I was three years old. My mama brought my sister and me here from Alabama, after she split from my daddy. I lived in the area of Green Hills, where my clothing store, H. Audrey, is now located. I lived an incredibly "un-Nashville" life for the first eighteen years. Then I got out of high school and started getting into the music business and playing every coffee shop in town.

I've had the honor of meeting many heroes and inspiring artists in Nashville, but my most memorable moment would have to be when I first met Bob Dylan. I was twenty-two. He was playing at TPAC, the Tennessee Performing Arts Center. His guitar player had done some work for me, so I met Bob backstage. There I was, meeting my absolute hero, and all he could talk about was how much he adored my grandfather, Hank Williams Sr. It was one of the most surreal moments of my life. Up until that point, I had understood Hank Sr. as a country legend, but that was the first time I realized his influence stretched far beyond the confines of country music. In fact, it was Hank himself who said, "I don't know what you mean by 'country.' I only write songs the way I know how." I reference that quote all the time.

I don't really know what to call my music. It's just real songs and real stories written on piano and guitar. I've never really been the type of writer to think about writing before I do it. I'm the girl who prays for songs and asks the good Lord above for creativity. Writing's been in my blood since I was little—I always kept notebooks of lyrics around. Songs just drop out of the sky, or they don't. "Waiting on June" means more to me than anything else I've written. It's a song dedicated to my maternal grandparents. It just came out of nowhere while I was washing dishes, of all things. I wrote "The Highway" at a gas station. I wish I knew when the songs were coming so I could be prepared, but I just have to be in waiting.

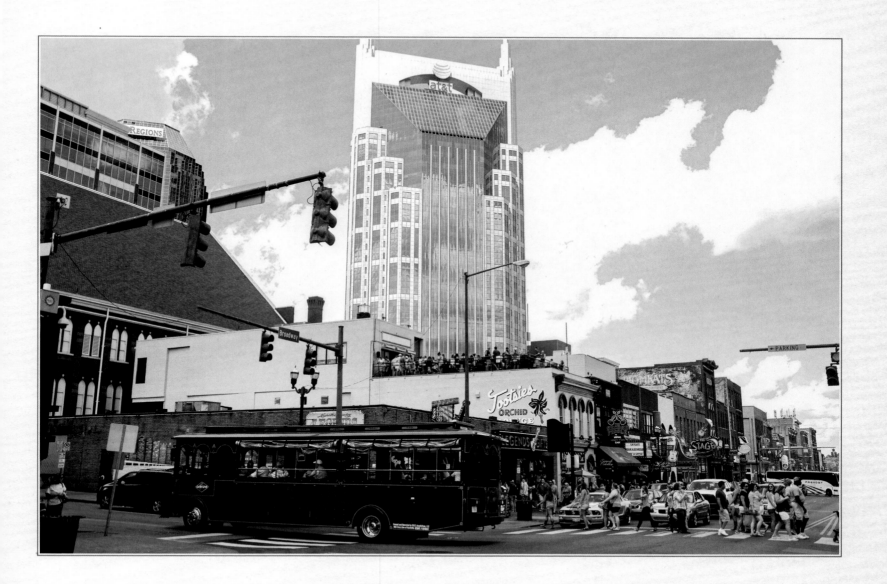

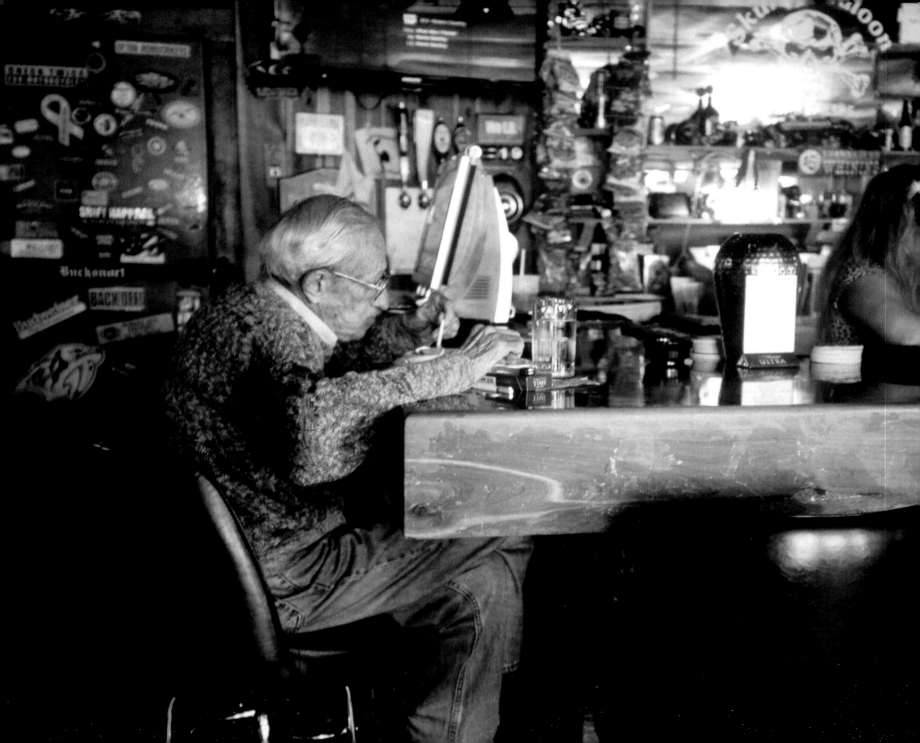

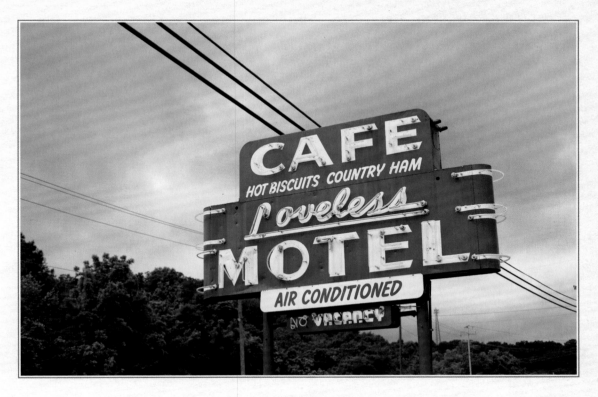

It's been incredible to see the recent changes in this city. In the last ten years, the growth has been exponential. I opened my clothing store in 2007, when there was barely anything to compete with. My modern-day general store, White's Mercantile, opened in 2013. It's been crazy to see the difference in the amount of tourists and people who have moved here just in that short time period. We have incredible restaurants, amazing retail, fabulous new music venues, and so many unique experiences that have just popped up in the last few years. This city is warm and friendly; it feels like a small town, but it has all the offerings of a big city. And my favorite part is, you can drive thirty minutes away and escape to the stunning countryside of Leiper's Fork, Tennessee. It's my personal getaway for song inspiration, mind-clearing, and time near horses and rolling hills. Truly healing to the soul! This city is authentic and magical. I will never leave. . . .—**HOLLY WILLIAMS**

ACKNOWLEDGMENTS

EVERYONE WHO APPEARS BETWEEN THESE PAGES has a story of struggle, perseverance, and victory. Boundless gratitude to each individual here who allowed us to enter their space and capture these intimate moments.

Special thanks to Buddy and Julie Miller for adopting me, teaching me, and loving me. I wanna be like you when I grow up.

Thank you to Greg Solano, Steve Jones, and Dustin Jones at Insight Editions for caring so deeply for this project. So proud to have collaborated on this with such an incredible team. Thank you for taking such good care of our work.

Sonya—from our first breakfast date at Frothy Monkey, we had an instant bond. I could see who you were through your photography. I felt like I already knew you. It was as if you had always been in my life but we were just meeting for the first time. The moments we've shared while photographing, from Mallorca all the way to Hollywood, are some of the most magical times of my life. Thank you.

Thank you to Ken Levitan. You're always there to give advice and help.

Thank you to my cousins, Karina, Alex, and Ben. My favorite drinking buddies. I love you all more than I can say.

And finally, my ultimate gratitude goes to my sister, Beth. You're the reason my heart is still beating. Thank you for never leaving me.

—KATE YORK

I ALWAYS DREAMED OF CREATING a book celebrating the people behind music. My dream came true, and I am truly thankful.

Thank you to the artists who trusted us, opened their sanctuaries, studios, hotel rooms, bedrooms, made us dinner while being photographed while simultaneously putting their children to bed.

Thank you Insight Editions for believing in this project. Steve Jones—we instantly spoke the same language on our passions for reportage photography and country music. Thank you Dustin Jones and Greg Solano, you've been incredibly thorough, reliable, and positive throughout.

Dave Brolan—thank you for helping get this book off the ground. You are an incredibly generous soul.

Kate—our synchronicity still floors me. It's as if we have been here before doing this. Thank you for hating Barcelona on our summer trip, which led to the Deia lunch where you stormed up the idea of collaborating our photography into a book. Thank you for being the light that you are.

Ella-Grace—this book is for you. You're the love of my life. Thank you for always being proud of me.

Thank you to the following: Lucie Silvas, my muse and sister, you put me on the path that was meant for me. The women in my family—we are survivors—Mum, Babcia, and Magda, the original country fan. My extended family who have provided consistent love and support: John O, TJ, Sam, Oli, Maureen, Mike, Anna, Laraine, David, Hero, Jon G., Suzie, Annie D., Evetts, Annie M., Lewis, Kath, Mads, Justine, Mark, Joel, Dad, Val, Baron and Michael Z., the original rock 'n' roll photographers. Big—You changed everything for EG and me, Knights in Shining Armor really do exist.

—SONYA JASINSKI

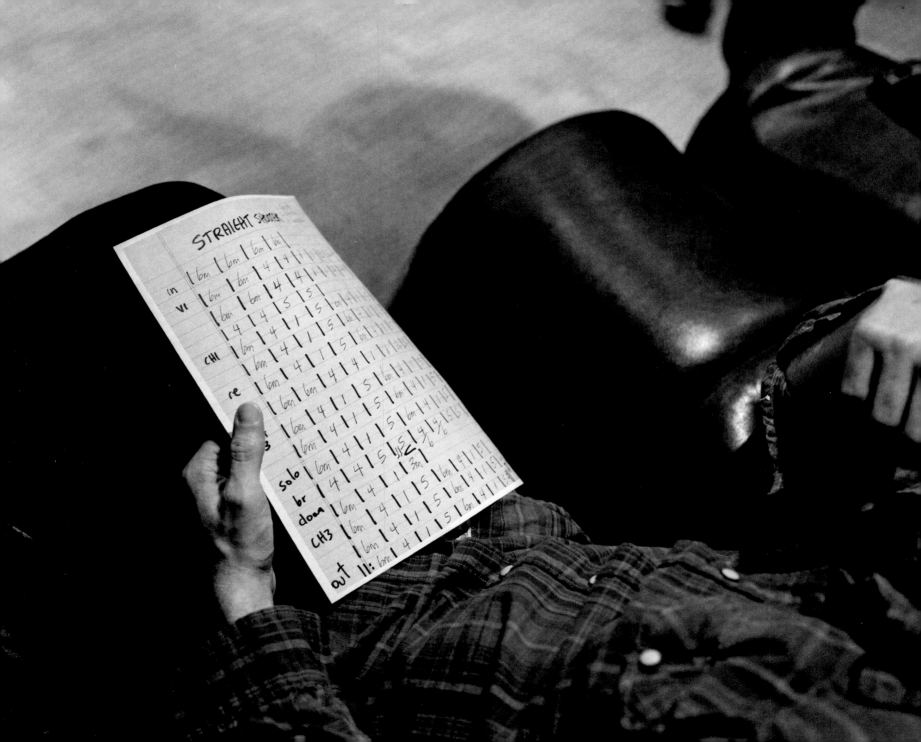

INSIGHT
EDITIONS

PO Box 3088
San Rafael, CA 94912
www.insighteditions.com

Find us on Facebook: www.facebook.com/InsightEditions
Follow us on Twitter: @insighteditions

Library of Congress Cataloging-in-Publication Data available.

ISBN: 978-1-60887-734-8

Publisher: Raoul Goff
Acquisitions Manager: Steve Jones
Art Director: Chrissy Kwasnik
Designer: Jon Glick
Executive Editor: Vanessa Lopez
Project Editor: Greg Solano
Production Editor: Rachel Anderson
Production Manager: Blake Mitchum

ROOTS of PEACE REPLANTED PAPER

Insight Editions, in association with Roots of Peace, will plant
two trees for each tree used in the manufacturing of this book.
Roots of Peace is an internationally renowned humanitarian
organization dedicated to eradicating land mines worldwide and
converting war-torn lands into productive farms and wildlife
habitats. Roots of Peace will plant two million fruit and nut trees
in Afghanistan and provide farmers there with the skills and
support necessary for sustainable land use.

Manufactured in China by Insight Editions

10 9 8 7 6 5 4 3 2 1

PAGE 2: The Girls of Nashville pose outside a venue in Austin, Texas. From
left: Caitlyn Smith, Heather Morgan, Sara Haze, Maggie Chapman, Sunny
Sweeney, Liz Rose, Aimee Mayo, Kree Harrison, and Shea Fowler.

PAGES 4 AND 163: Downtown Nashville's Music Row.

PAGE 164: An old man sits at the bar at Skully's Saloon in Nashville.

PAGE 165: The Loveless Cafe on Highway 100 in Nashville. The cafe has been
a destination for good Southern cooking since 1951.

PAGE 167: Score sheet of a demo session at Easy Eye Sound Studio in Nashville.